David Bellamy's
Winter
Landscapes
IN WATERCOLOUR

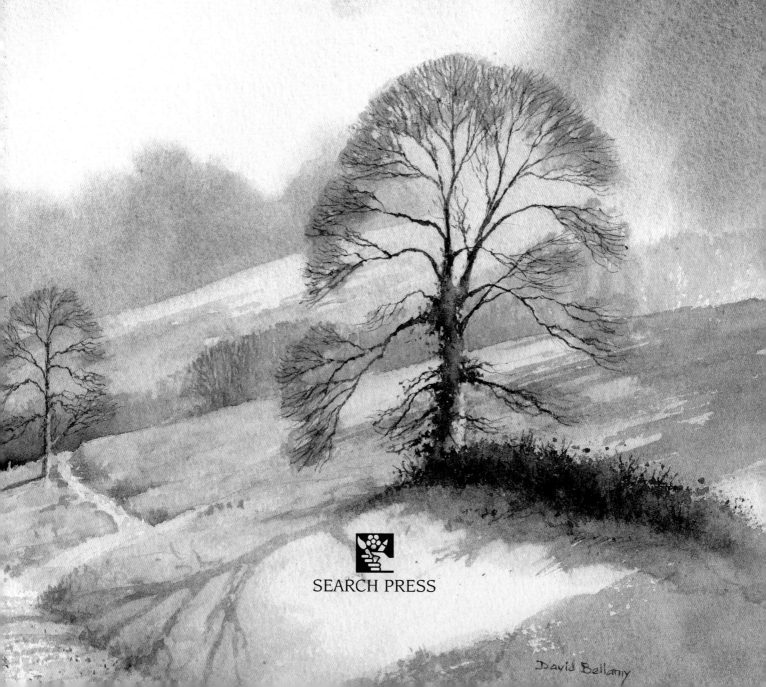

SEARCH PRESS

David Bellamy

First published in Great Britain 2014

Search Press Limited
Wellwood, North Farm Road,
Tunbridge Wells, Kent TN2 3DR

Illustrations and text copyright
© David Bellamy 2014

Photographs by Paul Bricknell at
Search Press Studios

Photographs and design copyright
© Search Press Ltd. 2014

ISBN: 978-1-84448-703-5

The Publishers and author can accept no
responsibility for any consequences arising from
the information, advice or instructions given in
this publication.

Suppliers
If you have difficulty in obtaining any of the
materials and equipment mentioned in this book,
then please visit the Search Press website for
details of suppliers: www.searchpress.com

Publisher's note
All the step-by-step photographs in this book
feature the author, David Bellamy, demonstrating
his watercolour painting techniques. No models
have been used.

You are invited to visit the author's website
and blog:

www.davidbellamy.co.uk

http://davidbellamyart.blogspot.com

Printed in China

Acknowledgements
*I am indebted to Jenny Keal for checking my
manuscript, and Sophie Kersey at Search Press for
her help and for editing the book.*

Front cover
**Farm in Winter
Sunlight**
28 x 35.5cm (11 x 14in),
300gsm (140lb) Rough
*This painting is also shown
on page 36.*

Page 1
Woodland Bridge
17.8 x 25.4cm (7 x 10in)

Pages 2–3
Farm Near Cadair Idris
28 x 15.2cm (11 x 6in)

These pages
**Farm, Staffordshire
Moors**
22.8 x 38cm (9 x 15in)
*The sketch for this painting
appears at the bottom of page 17.*

Contents

Introduction

Winter landscapes are popular subjects for painters in all media, yet many artists naturally shy away from the cold and discomfort of capturing such scenery. While summer days can make for pleasurable outings into the countryside in search of landscapes to paint, many artists find it a difficult time of year, with all that overwhelming greenery, and often, superb subjects are hidden behind massed foliage or riotous vegetation. In winter, these problems vanish: there is normally a greater variety of colour, and winter trees take on a different, at times romantic beauty in their naked splendour. Winter light is strikingly different from that of summer, giving the artist more opportunity for dramatic mood and heightened accentuation of a motif. Landscapes under snow offer an excellent opportunity to study the reflections of light and colour. The landscape environment is one of enormous complexity for the artist, and deep snow goes a long way to simplifying this subject for us.

Working outdoors in the coldest weather has never been universally popular. Among the French Impressionists, who took great pains to work directly from nature, only Monet, Pissarro and Sisley did any substantial work in the snow. Monet, in particular, was a hardy soul who painted outdoors in the harshest of winters, and was sometimes spotted working at his easel in deep snow, clothed in three overcoats, with a heater at his feet and his hands in gloves. These days we have far more efficient winter clothing and aids to working outdoors in less than perfect weather, but I am not suggesting for a moment that you should subject yourself to the most chilling and bleak conditions in which to paint or sketch. There are now easier ways of capturing even the coldest of winter scenes than following Monsieur Monet's example.

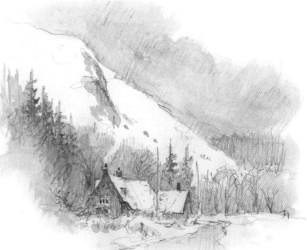

Elan village under snow

This book aims to take you from painting the fascinating scenery of late autumn, when the landscape is at its most colourful, through winter when all is laid bare, and on into the snow-covered countryside with its landscapes of quiet beauty and new challenges.

6

It ends with a short chapter on early spring. The seasons can at times merge into each other, to give delightful days of warm, sunny moods amid raw, snow-bound landscapes, making it a joy to be out recording the scenes in sketch or photographic form. I shall show you how to capture these moments, make full use of their atmosphere and lighting, and respond to the original material in your painting at home.

Some of the best days for capturing landscapes at their most dramatic are when there are heavy showers followed by strong sunshine. The countryside can positively sparkle and exude a sense of fresh excitement. Whether you can't wait to get out sketching in wild flurries of snow, prefer to work from inside a warm car, or paint from a bedroom window as many of the Impressionists did in the depths of winter, you should find much to inspire you in the following pages.

An Cearcallach, Scottish Highlands
30.5 x 38cm (12 x 15in) 640gsm (300lb) Rough

In this Highland scene, sunlight enhances the warm late autumn colours and evening mist adds a hint of mystery to the background. The summer midges have gone, the air is still, and the gentle evening sunlight makes it a pleasure to be out painting as winter approaches.

The yellow-orange tints were achieved with various mixtures of gamboge and cadmium orange and the wine-red massed birch twigs with permanent alizarin crimson. The foreground was accentuated with light red. This is a time when you can happily run riot with your reds.

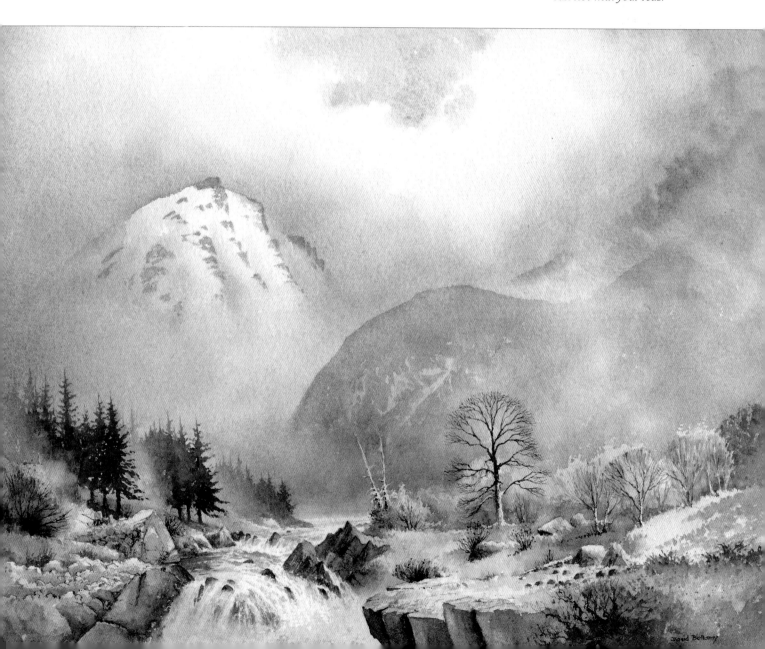

Materials

Paints

Watercolour paints are available in tubes, pans and half-pans. I normally use half-pans for outdoor sketching, and this is supplemented with tube colours on expedition or travel abroad. For the larger studio paintings, tube colours are essential as one can quickly mix large washes. Choice of colours is up to the individual, my own being fairly traditional with a sprinkling of modern pigments. I always work with artists' quality paints as they are more powerful and finely ground, but the students' variety are cheaper and there is not a great difference in quality with many colours. If you are new to painting, start with just a few colours and get to know them well before adding more. My basic colours are: French ultramarine, burnt umber, cadmium yellow pale, cadmium red, cobalt blue, Winsor blue or phthalo blue, alizarin crimson or quinacridone red, new gamboge, light red and yellow ochre, plus white gouache for minor highlights.

Add the following colours when you feel confident, but preferably not all at once: burnt sienna, raw umber, aureolin, viridian, indigo, cerulean blue, Naples yellow, cadmium orange, raw sienna and vermilion.

All the paints mentioned above have excellent permanence. Study the manufacturers' labels and leaflets to avoid any fugitive colours. These will also tell you if the colour is transparent, opaque or falls between the two.

Paper and sketchbooks

Watercolour paper is best bought in imperial-sized sheets, which are cheaper and can be cut to whatever size and configuration you wish. Pads, and blocks that are glued all round the four edges so that you don't have to stretch the paper, are good for working away from home. Usually the paper comes in weights of 190gsm (90lb), 300gsm (140lb), 425gsm (200lb) or 640gsm (300lb), with some manufacturers having a more extended range. The 640gsm (300lb) paper is as thick as cardboard; the 190gsm (90lb) version rather flimsy and prone to cockling. The 300gsm (140lb) paper will most likely need stretching before painting unless you work on really small sizes, so many people find the 425gsm (200lb) paper the ideal weight, as it does not need stretching unless you are painting larger works, and it is less expensive than the 630gsm (300lb) type.

Most papers come in three types of surface: Rough, Hot Pressed (smooth) and Not (or Cold Pressed). Hot Pressed paper is excellent for fine detail, but you may find it best to leave this surface until you are more experienced, as it dries rather more quickly. A Rough surface is extremely effective for creating textures or ragged edges, or for laying a broken wash with the dry-brush technique, although it is not best for fine detail. The most popular paper is the Not surface, which falls between the other two types in degree of smoothness.

Buy a few sheets from different manufacturers to test which suits you best. Most of the paintings in this book were done on Saunders Waterford paper.

Brushes

The finest brushes for watercolour are undoubtedly sable, though there are excellent synthetic brushes on the market. Kolinsky sable brushes have a fine tip, a large belly to hold copious amounts of paint, and the ability to spring back into shape and not lie limp after one brush stroke. A good compromise, if you find sables too expensive, is to buy a brush of mixed sable and synthetic hairs. Large squirrel-hair mops make lovely wash brushes, although they are prone to losing the odd hair now and then.

The minimum brushes would be a large squirrel mop for washes, a no. 7 or 8 round, a no. 4 round, a no. 1 rigger and a 13mm (½in) flat brush. Add a no. 10 or 12 round and a no. 6 round when you feel the need and you are well set up. More specialised brushes for certain applications, such as a fan brush, can also help on occasion, but are not essential. Take care of your brushes and they will last well. Wash them out with clean water after use.

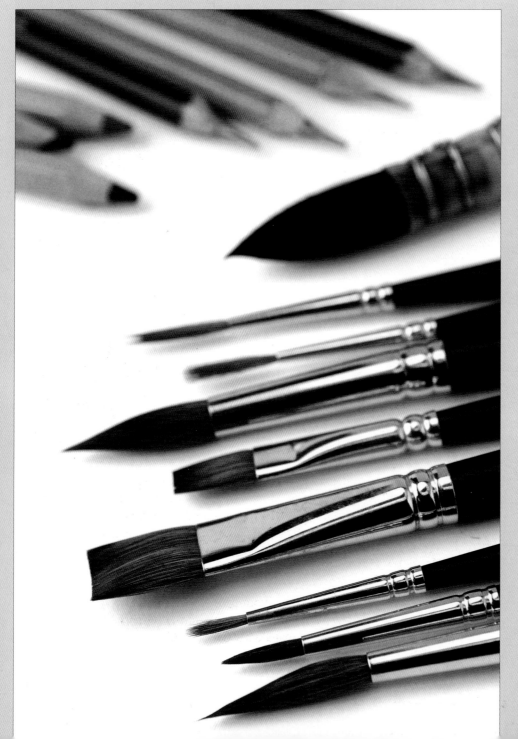

The brushes used in the step-by-step demonstrations in this book, from front to back: a no. 7, no. 4 and no. 1 round, a 13mm (½in) flat, a 6mm (¼in) flat, a no. 10 round and a no. 2 and no. 1 rigger, with a squirrel mop.

Other materials

At least one drawing board, a selection of pencils from 2B to 4B, a putty eraser, a soft sponge, at least one large water pot, masking fluid and a scalpel are all essential items. Also useful are bulldog clips, an old toothbrush for spattering, tissues and rags. I find a plant spray is useful to speed up the mixing of colours accurately, and occasionally for spraying over a damp wash to create a speckled effect. If you intend stretching paper, then a roll of gummed tape will be required.

You will need a large palette on which you can lay out the colours you are using, many of which will be for small areas of detail, and some for slightly larger areas. A palette with deep wells is needed for mixing up pools of colour for the main washes. Many artists prefer to use a saucer, butchers' tray or large plate, and so long as it is white and does not affect the way you see the colours, this is perfectly fine. For a large wash, the whole saucer would be needed, but for small detail, many mixes can take place on one dinner plate.

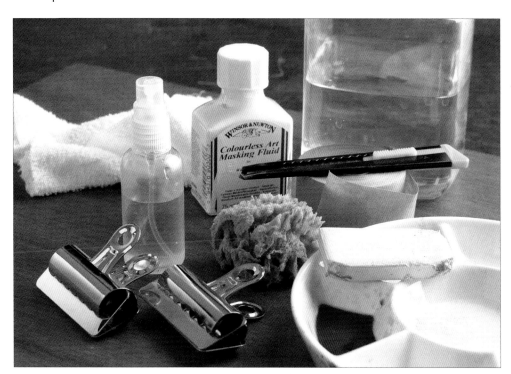

Sketching outdoors

If you are tentative about sketching outdoors, then start with a minimal kit (shown right) of an A5 cartridge pad, a couple of graphite water-soluble pencils and a water brush, which contains its own water supply in the handle. This enables you to work quickly, wet or dry, without fuss. Try working with this, and when you gain confidence, add a small box of watercolours in half-pans, a few brushes and a water pot. Most watercolour boxes include an integral palette in the lid. I sometimes use Derwent Inktense blocks, water-soluble ink blocks, for sketching. Cartridge paper can be difficult to work on with watercolours until you are used to it, so you might prefer a small book of watercolour paper. All this is stored in a belt bag, with gloves to keep out the cold. Later you can expand this kit to suit your needs. I also carry larger sketchbooks and additional materials in a rucksack.

Basic brush techniques

How you handle your brush is critical to the success of your painting, and time spent practising various brush techniques will be well rewarded. For some techniques, such as creating texture with the side of the brush, or the stabbing technique, for example, you can happily use an old, worn brush – in fact it makes sense to do so, as you don't want to wear out those marvellous new, well-pointed sables too quickly – while for delicate, detailed work, you need to reserve your best brushes and keep them in good order. I also use an old, large brush for mixing colours. In this section we look at a few basic techniques on how to achieve certain effects with your brushes.

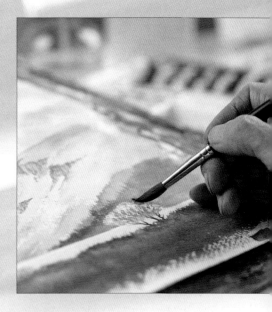

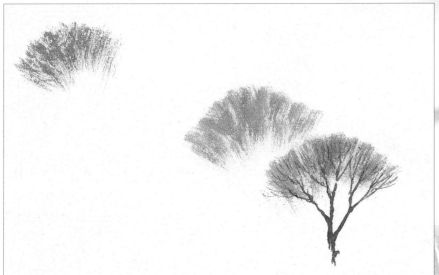

Stabbing method

This is extremely useful for suggesting masses of twigs with a few strokes. Simply stab the brush down onto the paper at the point where you want the extremity of the twigs to start, and then drag it towards the centre of the bush or tree. Doing it this way suggests an energetic effect. Practise it on scrap paper first to ensure the brush contains the right consistency of paint. The left-hand example was done with a no. 4 round brush, the right-hand pair with a 6mm (¼in) flat brush.

12

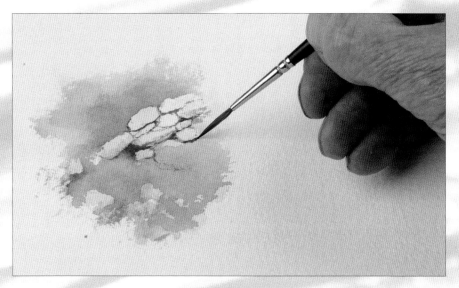

Varying marks and lines with a rigger

By putting varying pressure on a brush, you can create more interesting marks and lines, as in this section of a dry-stone wall painted with a fine rigger brush.

Creating textures with the side of a brush

With this technique, the brush is dragged across the paper on its side, diagonally in this case, where a rough mountain slope is descending to a lake. By testing the effect on spare paper, you can assess how liquid to make the mixture. On Rough paper, this method is extremely effective in creating broken washes, but it still works well on a Not surface. It is hard to beat when you need rough or broken texture, sparkle on water or boulder scree tumbling down below a crag.

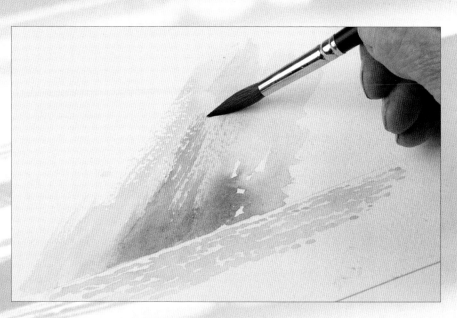

Flat brushes for lifting out paint

Flat brushes are extremely effective for lifting out paint when brushed sideways as shown. It is fairly easy to create light tree trunks in this way without having the chore of working round the tree shapes with a dark wash in a negative fashion. They are also useful for removing unwanted paint. For this type of technique, you need to ensure the brush is one of the thinner flats, as this will ensure more delicate results.

Working outdoors in winter

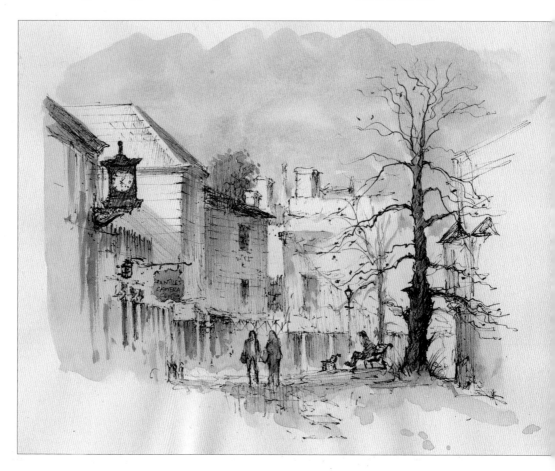

Your approach to sketching and painting outdoors in winter will be conditioned by your general experience of the outdoors. Some people enjoy being out in winter time and perhaps stopping to sketch for a limited period, while others loathe the idea. I'm lucky in being able to paint watercolours in below zero temperatures in the Arctic, but when the thermometer falls well below that, I retreat rapidly into the tent or hut.

No landscape artist wants to avoid painting the countryside in winter, so how do we make life bearable, even enjoyable? I have always been an outdoorsman, and aware that without the right clothing, it can be purgatory hanging around outside in the cold. Layered clothing is better than thick garments. Modern thermal underwear that wicks away perspiration, covered with a warm shirt and a lined fleece jacket is an excellent combination, and over this a waterproof and windproof outer shell will give you all-round protection. A waterproof hood is of great help, but don't forget a woollen hat as you lose one third of your body heat through your head. Lined trousers are marvellous for outdoors in the cold. The thin, but warm insulated gloves allow you to use a brush and pencil easily, although fingerless gloves, including some versions with a flap to cover all while you are not sketching, are also available. If I am sitting around and not doing much walking, then I often take a padded down jacket along, but it tends to get too hot if I walk any distance. All these items can be obtained in mountain gear shops and some fishermen's shops are also excellent sources.

The Pantiles, Tunbridge Wells

This pen and wash sketch was carried out over afternoon tea sitting outside a café in Kent, UK. Although winter was just about past, it was cold, but many like to sit outside even in the dead of winter, enjoying the sunshine, and so long as you are well wrapped up, carrying out a sketch while you take refreshments can be rewarding. Just don't dip your brush in the tea.

14

Not everyone can tolerate sketching outside, but there is still a lot you can do to obtain reasonable images. Hopping out of a warm car into an icy blast does not auger well for those inspirational moments, so you need to prepare well. Keep your sketching equipment simple and ready for action. Have a flask of soup, coffee or something else hot, ready to revive you. Don't forget to take photographs at various angles and zooming distances – perhaps a photograph may be all you can manage, but that may be enough for you to work from. Maybe you can work from the car itself: hatchbacks can make excellent places from which to sketch. Jenny, my wife, often uses hand-warmers if it's really cold. She just slips them into her gloves. A blanket in the car might also be sensible.

As far as sketching is concerned, wind blasting across snowy landscapes can be a real killer, so find some shelter if possible. At times, I have had to dart in and out of the shelter of a boulder or crag to render an important part of the scene that I can't quite see from my sanctuary, and moving around does help keep you warm. Many a time I have danced round rocks or trees to combat the cold, hoping, of course that no one is watching! Walking and sketching is a superb way to work, as fifteen to twenty minutes of walking will generate plenty of heat to allow you to sketch for a while in all but the worst weather.

Jenny sketching

My wife, Jenny, tends to suffer badly if conditions are too cold, but when well wrapped up, as she is in this scene, she can work quite happily for a while.

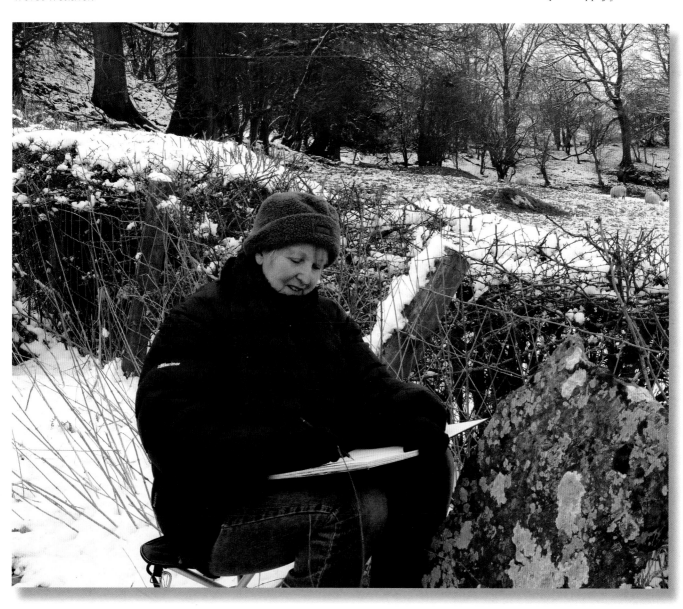

If you become concerned about the cold, then you need to get back into the warm as soon as possible. Often a few rapid strokes of the pencil may suffice to achieve your aim of recording the most important aspects of a scene. Then, once in the warmth of a car, tent or building, it is worth noting down any vital bits of visual information, such as colours, that you need to recall later. If, for example, there is a line of trees, all of the same species but different shapes and heights, I will draw the most important one in a fair amount of detail and then simply create an outline to indicate where the others appear. Later I can draw these in detail. Likewise, I often start off the tone at a critical point in a passage and fill the rest in later. I am often amazed at how clearly I can recall elements, tones and even colours in a scene simply by looking at the squiggly mass of sketchy lines I have drawn with this visual shorthand method. An important point to remember when sitting down outside is that it is easy to forget your situation when you are engrossed in an exciting composition, and thus you can become extremely cold without realising it. The answer is to remember to jump up every now and then and perhaps walk around vigorously for a minute or two.

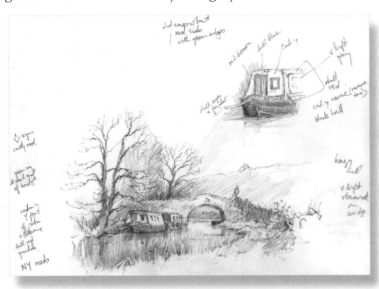

Welsh canal

I did this sketch beside the Brecon & Abergavenny Canal in Wales. Canals make interesting subjects and are readily accessible in winter, when you can walk and sketch without any great physical effort. Bridges, narrow boats, buildings, warehouses, and all manner of associated subject matter make for a variety of interest. If I work in monochrome, I often add colour notes and other points of interest, and here I have drawn a larger-scale detailed section of the barge prow so that I have all the information I need when carrying out a larger painting of this scene.

Yorkshire Farm in Sunshine
23 x 30.5cm (9 x 12in)

Although it is winter, there is a lovely sense of warmth in this painting, originally sketched on a sunny February day after a short hike in Yorkshire, UK. With bright colours on the fields and strong cast shadows, the suggestion of sunshine is accentuated. Note the stonework on the buildings and dry-stone wall does not include every stone, with moss covering much of the latter. This lost and found style prevents the painting from becoming too overworked. Many scenes like this can be completely hidden behind thick foliage in summer, yet they are fairly easy to capture on a fine winter's day.

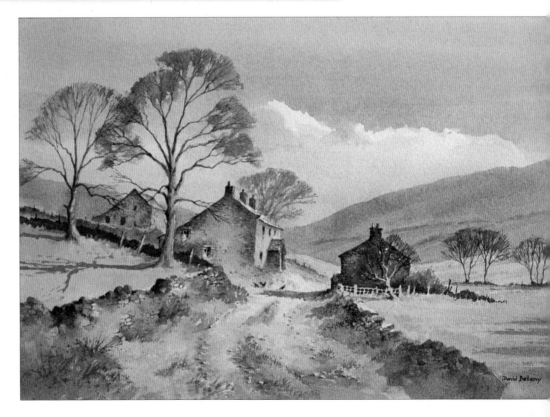

Rapid watercolour sketching in the cold

If you wish to work in watercolour in less than perfect conditions, this is a greater challenge, and is best tackled after you have some experience of drawing outdoors in such conditions. For this I tend to lay washes down and then draw into them with a dark watercolour pencil as they are drying. This is fast and efficient and usually I can keep painting even when parts of the sketch remain wet, as a strong watercolour pencil line can act as a barrier, containing the wash to a great extent, provided the angle of the paper is not too steep.

One advantage accrues from this system of rapid working outside, and it is rarely mentioned in books. By sketching in this way, you learn to seek out the most important features in a subject and draw and paint them with bold, confident strokes, at the same time simplifying the scene. This will immeasurably help your painting at home.

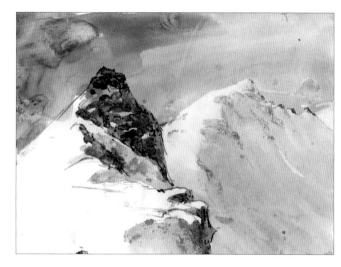

Summit of Parkhouse Hill

Sometimes the scene is simply too good to miss, whatever the weather conditions, and on this day they were frightful. I include this watercolour sketch because it shows that even with ferocious gusts and below-zero temperatures icing up the wash, you can achieve something that can be used as a basis for a later painting in the calm of the studio. Speed was achieved by using only one colour and drawing with a water-soluble pencil while the washes were still wet.

Farm at Shaw Bottom

Deep snow lay all around, but on the rough moor, much of it had been blown away or fallen into tall grasses and ditches. In this sketch, done on Hot Pressed paper, I rapidly splashed washes on with a no.10 round brush, avoiding the roofs, and immediately began drawing into the wet wash with a black watercolour pencil. I made the background darker in order to make the snow-covered roofs stand out starkly, and could see more of the horizon than is revealed in this sketch. While it was still damp, I pulled out some lighter areas with a flat brush and then spattered other colours over the foreground, some onto damp paper. Working quickly in this way gives a lovely sense of spontaneity, and there is less chance of frostbite for the artist.

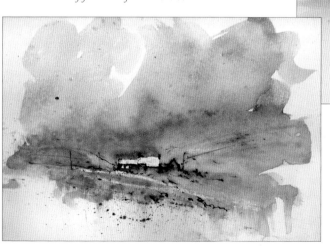

Snowfall at Meonstoke

Despite a thin covering of snow, it was fairly warm when I sketched this scene, so I could take my time. I prefer to sketch snow scenes in watercolour, rather than just pencil, because it is excellent at capturing the subtleties of tone and colour in snow.

Late autumn

This is the time when autumn runs into winter and seasonal boundaries become blurred. As trees shed their leaves, it is a great opportunity for the landscape artist, with all that massed green foliage being replaced by exciting colours and the interesting bare structure of trunks and branches. Early snowfall can sometimes cloak distant hills and mountains, yet vivid autumn colours are still resplendent in the foreground, providing an exciting combination. It really pays to be ready to capture the transient scenes at this time of year, with some potential paintings in mind, as gales and storms can quickly change the state of trees in autumn. Certain local trees can put on a spectacular display of colour every year, so watch out for these. Of course, once you have experienced these beautiful days, it is fairly easy to transform your original autumn sketches and photographs into a composition with a snowy background, or vice-versa. Changing the season in this way can offer you fascinating new possibilities with a favourite subject. In this section we shall look at these autumn colours that can linger well into the depths of winter, and, most importantly, at how a studio sketch can help you structure your composition and introduce new elements into the scene. We will also consider some of the lovely atmospheric effects we can encounter at this time of year.

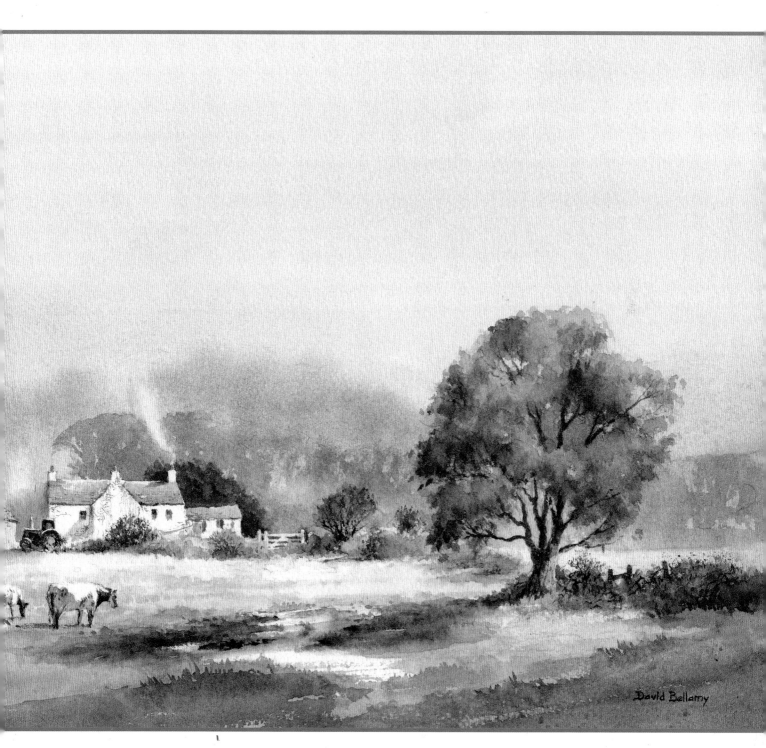

Farm in Autumn Sunlight

23 x 38cm (9 x 15in) Not

When you are fed up with an overwhelming prospect of summer greens, it sometimes pays to turn your summer landscape into an autumn one, which is what I have done here. I also often add a little autumnal foliage into my winter scenes, to warm them up. This is easy if you have examples of autumn foliage and trees to work from. Here, I added in the red tractor from my reference collection, as it helps draw the eye to the farm buildings.

The importance of the studio sketch

In many cases it is easy enough to work directly from a sketch or photograph without any problems, but what if you want to beef up the composition with stronger tones, inject a different atmosphere, add figures or animals, or make changes to various features? This is where the studio sketch is invaluable, and with complicated subjects it is worth doing several before choosing your course of action. Studio sketches can be a simple pencil sketch – use a soft grade such as 3B or 4B, charcoal or water-soluble graphite pencils. I sometimes use Derwent Inktense blocks, water-soluble ink blocks which can give a quick, broad image over which you can wash water.

Having a collection of sketches and photographs of objects, animals, figures and various features to add to your composition will greatly enhance your paintings. These can be used to replace less attractive features, so long as they are in keeping with the subject matter, and it pays to constantly build up your reservoir of images. Used in combination with the studio sketch, they will enhance your compositions.

I made alterations to the above scene to improve the composition. I often do this automatically, as in this case, but if you are inexperienced, or presented with a more complicated subject, then a studio sketch is essential, as the following example will show.

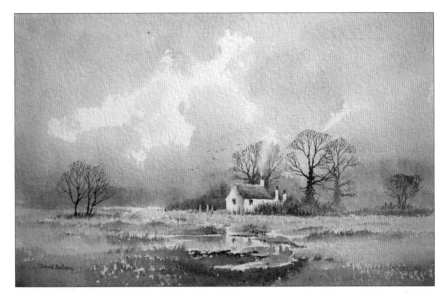

Cottage near the River Wey, Surrey
20.3 x 28cm (8 x 11in)

I felt that this painting needed a little tweaking to strengthen the composition: the left-hand distant trees were deliberately faded away, even though they could be clearly seen; I added rising smoke from the chimney to suggest human presence; the gable end of the cottage was rendered with a graduated wash to make it stand out; I varied the tones on the right-hand trees to avoid monotony, and finally added a puddle for foreground interest.

Aberedw in Autumn

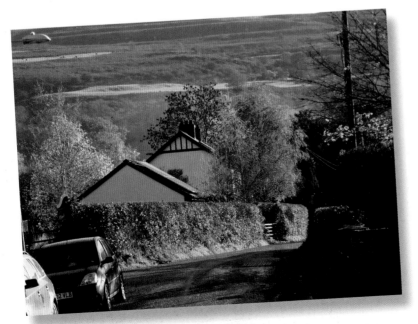

The reference photograph

This scene, near my home in Wales, has many attractive features, but would benefit from a number of changes to turn it into a more exciting composition.

20

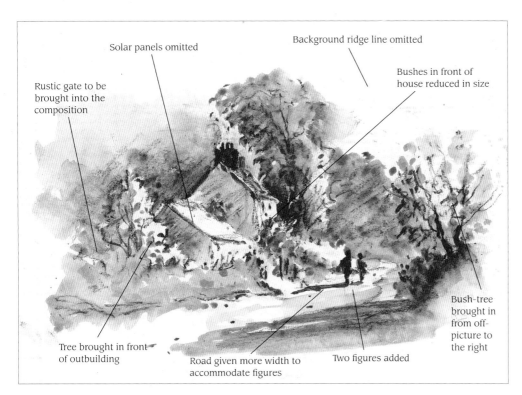

Solar panels omitted

Background ridge line omitted

Bushes in front of house reduced in size

Rustic gate to be brought into the composition

Tree brought in front of outbuilding

Road given more width to accommodate figures

Two figures added

Bush-tree brought in from off-picture to the right

The studio sketch

Based on the photograph and original sketch, this is a rough studio sketch done with a water-soluble ink block, then washed over with water. This helped me to work out the tones and lighting, which is coming from the right. At the end I put in a couple of figures to see if they improved the composition, and moved in a bush-tree which was actually too far over to the right to be seen in the photograph. I decided to bring the left-hand tree slightly forward, in front of the outbuilding, to break up the hard lines. I also reduced the size of those in front of the house to give the building more prominence.

Aderedw in Autumn: the finished painting
15.3 x 23cm (6 x 9in)

The neatly cut hedgerow jarred with my sense of wild chaos, so I introduced a more uneven version, left out the solar panels on the outbuilding and created more space on either side. Background ridges can sometimes look awkward in a painting, so I brought in some mist to eliminate that problem. After further deliberation, I included two figures chatting in front of the house. I also darkened the small tree on the right to suggest a greater sense of depth in the composition, as dark tones tend to push the rest of the painting into the distance.

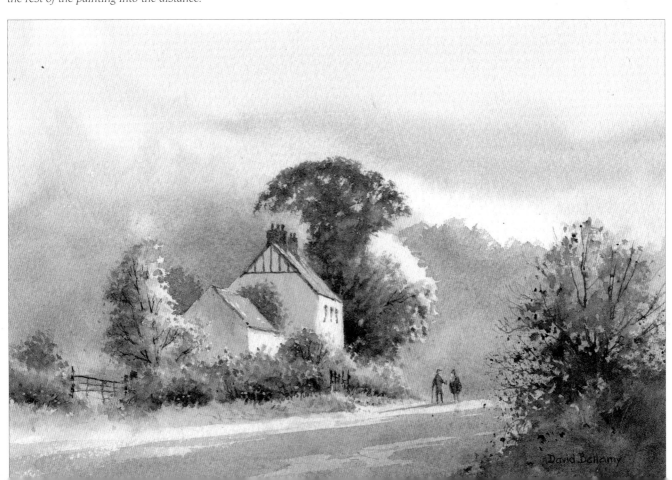

David Bellamy

Misty scenes

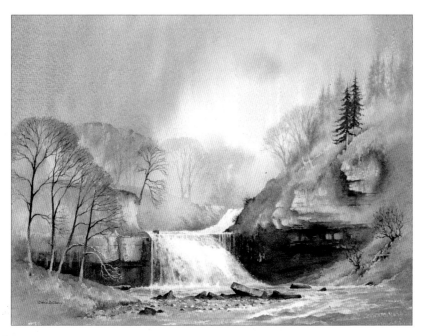

West Burton Force
28 x 35.5cm (11 x 14in) Rough

The wet-into-wet method, in which paint is added into a wash that is still wet, is normally the most effective way of suggesting a misty scene, but in this watercolour I have used two techniques as a way of suggesting varying degrees of mist. In the centre, directly above the more distant waterfall, a mixture of cadmium red with a touch of cobalt blue has been applied into a damp background wash of very weak yellow ochre to just faintly hint at the presence of trees in the mist. When the paper had dried completely, I used the same mixture with slightly more cobalt blue added to paint in the two trees that stand centrally above the main falls, while at the same time rendering the bank and rocks below them. I also added trees further to the left in the background. These features all dried slightly stronger than they now appear. Once the paper had dried, I gently sponged over the background trees with clean water and a natural sponge to push them back into the distance, though they are still strong enough to appear in front of those done wet into wet earlier. By combining these two techniques, you can create greater depth in misty scenes. The strongly etched tree on the left that looks as though it is about to fall into the pool adds further depth.

Glen Muick

20.3 x 30.5cm (8 x 12in) Not

Mist and fog can truly enhance the mood of a painting, but they are also effective devices where you wish to reduce the effect of a strident and dominating ridge, ugly background features, or repetitive detail such as the massed conifer slopes in this Highland scene. Here the wet-into-wet method really comes into its own, and if you wish to render the whole misty background in one go, you have to work quickly before the washes dry. Alternatively, you can work on one background section, allow that to dry completely, then re-wet the paper and move on to paint in the adjacent part of the background. If you are new to this technique, it is best to begin with simple compositions like the top left quadrant here, working up to more complicated effects when you gain confidence.

The autumn colours on the bushes are important to counter the overall drab grey-green, and it helps to position these where they will draw the eye to your centre of interest. Less prominent ones can be used to break up large areas of less importance and also create balance. Juxtaposing strong detail against misty passages will make your detailed features stand out. I have played down the detail in the water, as it is easy to overdo this, especially in turbulent rivers, but I splashed some yellow ochre into the falls. This suggests peat content and adds interest without the need for detail.

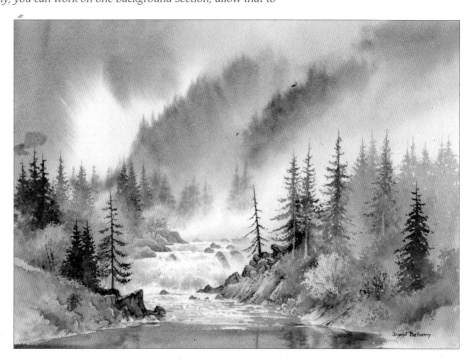

Colours for autumn and winter scenery

In these examples of autumn trees, I have used a number of yellows. You can use combinations of different colours to achieve a similar result, so it is important to experiment to see which colours work best for you, not just in the tree itself, but also in the adjacent colours.

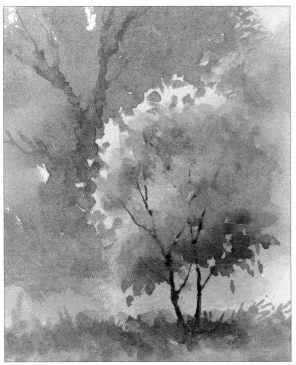

Here I used aureolin for the light extremities and brought in some cadmium orange lower down. The dark green background shows up the aureolin well.

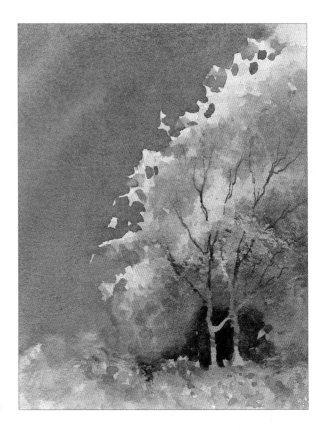

Here, new gamboge was applied all over the foliage, then cadmium orange brushed into the wet area apart from the left-hand edge. After the trunks and the shadows were put in, I allowed the whole painting to dry completely before laying a dark purple wash across the background. When you compare this to the painting above left, it stands out more, not just because the purple is a darker tone, but because it is a complementary colour to the orangey-yellow.

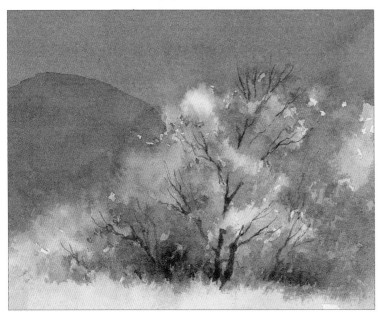

Autumn foliage with intermittent leaves

Light-coloured flecks of leaves and small clusters against a dark background can be really attractive, but they are annoyingly difficult to paint in watercolour. In this instance, I spotted masking fluid in places – mainly at the edges of the foliage – where I wanted the light-coloured individual leaves. You can also spatter it with a toothbrush if you wish. On removing the mask, I dabbed in the bright yellows and reds, allowing them to run together in places. They stand out most clearly against the dark grey.

23

Mixing colours

Colour mixing causes great problems for many artists, who seem to feel the need to copy every colour from the original precisely. Depending on how much of each colour you add, the results can vary considerably, and formulae based on colour names can go sadly awry, since various manufacturers' colours can be markedly different, even when the name is the same. Also, student colours can vary considerably from artists' quality pigments. Each artist needs to work out his or her own colour mixtures by methodically experimenting. Set aside some time to concentrate on producing a series of greens, for example, mixing not only blues and yellows, but other colours such as raw umber. Another time, work on greys or autumn colours, and gradually get to know your colours, making special note of those mixes that really appeal to you.

The choice of colours available for creating autumn foliage and vegetation can appear mind-boggling. Here I have created a few autumn mixtures, some with colours outside my usual palette. With each of the three pairs, I have used the same colours for both swatches, but for the one on the left, the mixing has been done on the palette and shows an even wash. On the right, I have dropped the colours on either side and let them merge, allowing parts to be wetter than others, thus creating slight runbacks for interest. Mixing on the paper like this can result in fascinating effects, particularly for autumn foliage. If you have yellows and reds different to those shown here, don't feel you have to go out and buy new ones. Try your own first, and only buy new colours if you really need them. Having too many colours can be confusing, especially if you are not experienced. You can achieve similar results with different combinations.

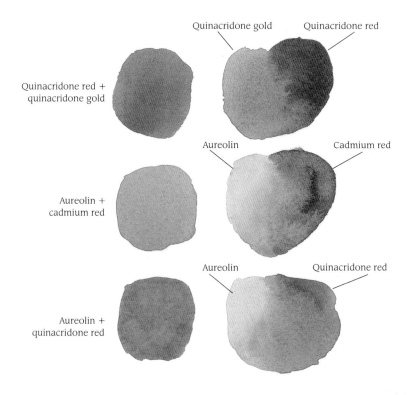

Quinacridone red + quinacridone gold — Quinacridone gold / Quinacridone red

Aureolin + cadmium red — Aureolin / Cadmium red

Aureolin + quinacridone red — Aureolin / Quinacridone red

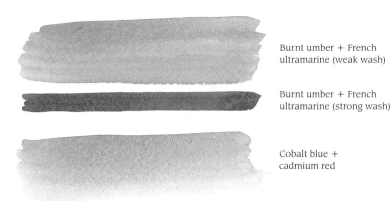

Burnt umber + French ultramarine (weak wash)

Burnt umber + French ultramarine (strong wash)

Cobalt blue + cadmium red

These grey mixtures are two of my most common ones. The burnt umber and French ultramarine one shows the two separate tonal strengths, illustrating that a lovely neutral grey can be achieved, or a really dark one. The cobalt blue and cadmium red mixture can produce a lovely warm purple-grey.

These examples should give you an idea of how to progress with your colour mixing. If you keep your results in a folder, you can always refer to them when you need something new.

Autumn colours with a snowy background

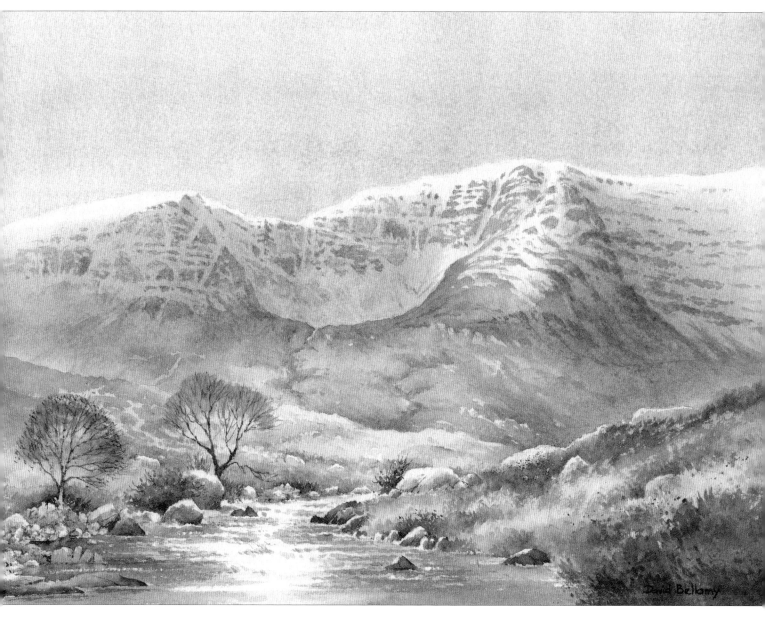

Applecross Mountains
20.3 x 30.5cm (8 x 12in) Not

The combination of early snow with autumn colours can create an exciting painting, and I always watch for these moments. In this view we have autumn colours not only on the trees, but also in the ground cover in places. Bracken can add lovely splashes of warm colour to a scene, so make full use of it when you can.

With their intricate sandstone terraces, the Applecross Mountains in Scotland present a complicated face to the artist. If, like me, you wish to suggest the character of the mountain, yet not overwork the detail, it is a challenging prospect. Losing the less vital parts of the mountain face in mist or shadow can work well. In this instance I decided to subdue the excess detail by laying a glaze of cobalt blue with a touch of cadmium red across the areas I wanted in shadow. This was done after I had painted in all the crag detail. Where the crags of the intricate terracing stand bathed in sunshine, I added weak light red into the crags mixture instead of the burnt umber used in the shadow areas. This creates the sense of catching the sunlight, which is coming from the left. With such detail on the mountain, I kept the sky as a flat wash of cobalt blue and burnt umber, with a soft edge between sky and the snow on the summit ridge.

The lower slopes just above the river were painted with Naples yellow, yellow ochre and some light red here and there, while keeping the tops of the boulders white to imply strong sunlight. I added more autumnal colours into the trees than were present, to further emphasise the season.

LATE AUTUMN WATERFALL

As winter approaches, seek out woodland subjects, especially streams. A patch of sunlight on autumnal foliage can make the scene come alive. Combine it with a cascade or sparkling stretch of water and you have a subject worth painting. Backgrounds in woodlands are often best achieved using a misty wet-into-wet effect.

Materials used

Saunders Waterford 640gsm (300lb) Not watercolour paper

Brushes: Large and small squirrel mops, no. 7 and no. 4 sable round, 13mm (½in) flat, no. 3 rigger and 6mm (¼in) flat

Colours: Naples yellow, cobalt blue, cadmium red, alizarin crimson, yellow ochre, light red, quinacridone gold, cadmium yellow pale, burnt sienna, French ultramarine, cadmium orange, burnt umber

Masking fluid and old brush

Old toothbrush and paper mask

1 Draw the scene with a 3B pencil. Apply masking fluid to the lightest areas of foliage, the falling white water and a few splashes either side. Use a large squirrel mop to wash water over the background, down to the stream, then take the smaller squirrel mop and drop in Naples yellow over the foliage area.

2 Brush a wash of cobalt blue and cadmium red across the sky, around the yellow, using the large mop, then brush in alizarin crimson and cobalt blue over the lower part of the sky.

3 Use the smaller squirrel mop to paint yellow ochre across the ground so that it blends with the sky colour. Use a thirsty (barely damp) brush to pick up excess water. Soften the bottom with clean water to avoid a hard edge.

4 Use a no. 7 sable round with a good point and a mix of cobalt blue and light red to paint in the background trees wet into wet. Paint the edge of the ground and suggest bushes, putting darker tone round the masked foliage.

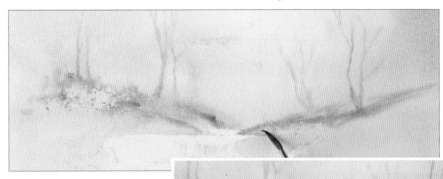

5 Add more light red to the mix to describe the contours of the ground nearer to the foreground. Working wet into wet, paint blobs of pure light red to suggest fallen leaves. Allow to dry. Change to a no. 4 sable round to blob quinacridone gold over the foreground. Allow to dry and soften any hard edges with a 13mm (½in) flat.

6 Use the no. 7 brush to paint a pale mix of cobalt blue above the white water. Add light red to darken the mix and sweep it across the water. Soften the edges with water.

7 Pick up cadmium yellow pale with a little cobalt blue and a touch of cadmium red, and paint this onto the rocks to suggest moss. Soften the edges with clean water.

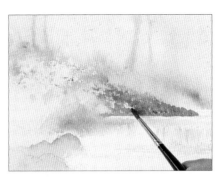

8 Mix cobalt blue with cadmium yellow pale plus a little burnt sienna and use the no. 4 brush on its side to paint the darker land behind the white water with dry-brush work. Add more burnt sienna to suggest dead leaves.

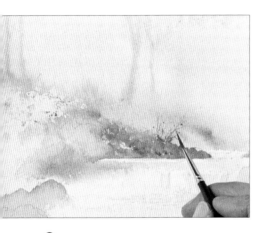

9 Use a no. 3 rigger to drag out paint from the wet wash, creating grasses and undergrowth.

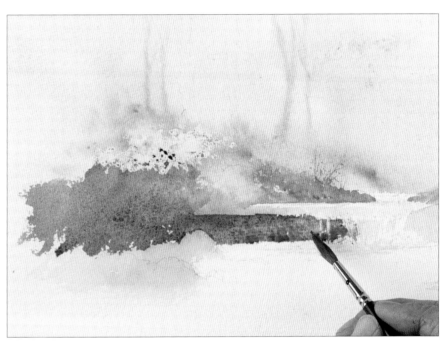

10 Mix French ultramarine and burnt sienna and use the no. 7 round to brush on the middle ground and the rock over which the white water runs. Drop in yellow ochre wet into wet.

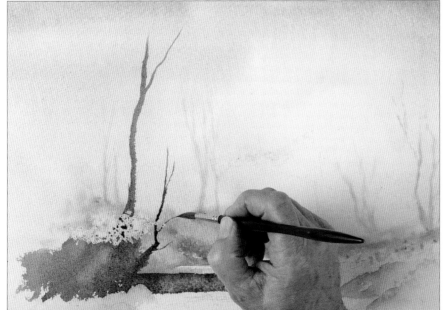

11 Use the same mix to paint tree trunks on the dry background. These sharper trees will push the previous ones into the background.

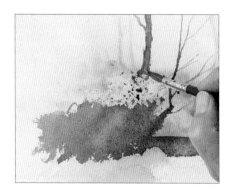

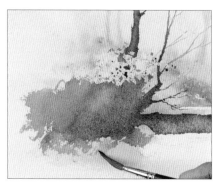

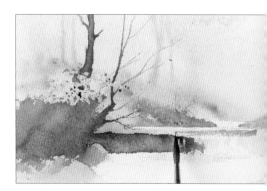

12 Add blobs of burnt sienna suggesting dried winter foliage, then drop cadmium orange into the wet tree trunk for texture and warmth.

13 Mix burnt sienna with a little ultramarine and use the brush on its side to scrub the colour over the foreground moss.

14 Paint cobalt blue with a touch of light red across the water to add tone, using the dry-brush technique.

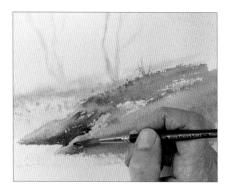

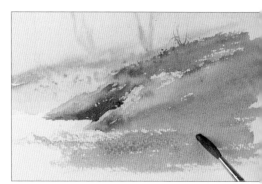

15 Use the same mix with a little more light red to sweep a broken wash across the land on the right, and add some vegetation with the point of the brush. Add tiny dots of burnt sienna for dried leaves.

16 Make a darker mix of burnt sienna and cobalt blue and take this down to the water's edge, then soften it in with clean water.

17 Carry the broken wash down to the foreground with the dry-brush technique, then drop in pure cobalt blue for variety.

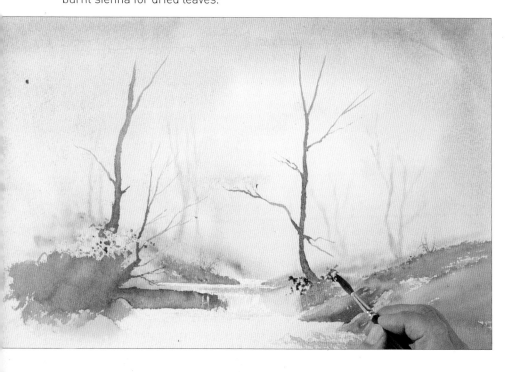

18 Paint the tree on the right with French ultramarine and burnt sienna, then drop in a green mix of cadmium yellow pale and cobalt blue lower down, wet into wet. Drop in yellow ochre higher up, then dot burnt sienna around the base of the tree for undergrowth and dead leaves.

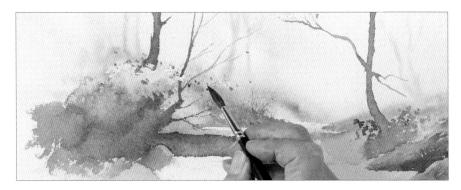

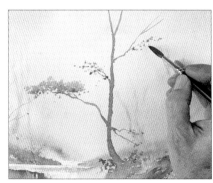

19 Remove the masking fluid from the foliage and use the 13mm (½in) flat to soften the resulting hard edges with water. Wash quinacridone gold across the foliage, then drop in cadmium yellow pale wet into wet. Drop in cadmium red. Add a few blobs of the same colour for winter leaves.

20 On the right-hand tree, the foliage is dark against light so drop in light red first using the no. 7 brush, then quinacridone gold. Add foliage to the rest of the tree in the same way.

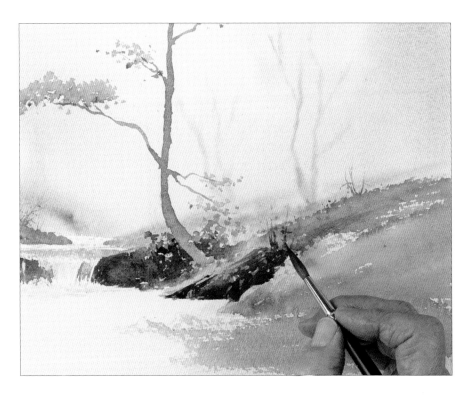

21 Make a dark mix of French ultramarine and burnt umber and paint the dark rocks near the water to define the bank. Drop in burnt sienna.

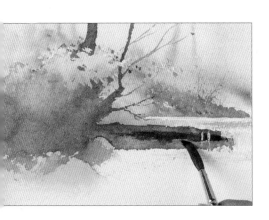

22 Mix burnt sienna and French ultramarine and paint the strata of the rocks to the left of the waterfall, then soften the edge with a damp brush.

23 Add texture to the right-hand tree trunk with the same mix and dry-brush work. Extend the branches and twigs.

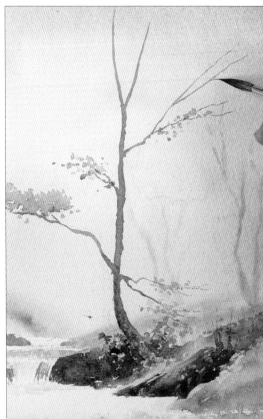

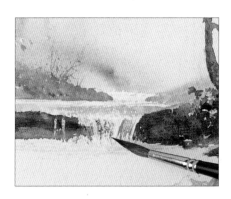

24 Use dry-brush work down the waterfall, over the masking fluid, with burnt umber and French ultramarine.

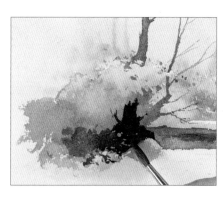

25 Add tone to the lower left-hand trunk with the same mix and drop in light red.

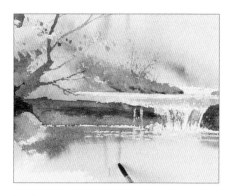

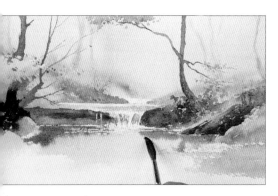

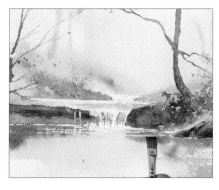

26 Wet the water area with clean water, then apply a pale mix of cobalt blue and cadmium red. Drop in a little Naples yellow, then paint wet-into-wet reflections with burnt umber and French ultramarine.

27 Use a damp 6mm (¼in) flat brush to lift out reflections of the white falling water, and ripples across the still water.

28 Use the no. 4 round brush and burnt sienna and French ultramarine to add a little detail to the far shore, then paint reflections of the background trees with cobalt blue and cadmium red.

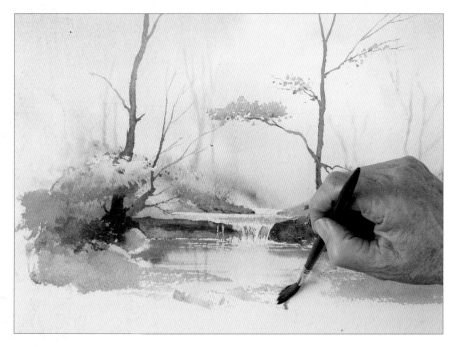

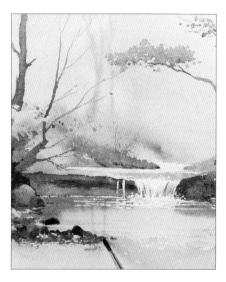

29 Add darks to the shadowed underside of the bright foliage on the left with cobalt blue and light red, then use the no. 7 brush to glaze this mix across the foreground. Pull it out to create texture on the water using dry-brush work. Allow to dry.

30 Remove the masking fluid from the waterfall and use the no. 4 brush and French ultramarine and burnt umber to add tone to it, then sharpen up the tone at the water's edge with the same mix, creating a rocky texture and adding more burnt umber as you come forwards.

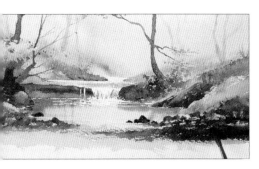

31 Drop yellow ochre into the left-hand rocks wet into wet. Create rocky texture on the right in the same way, then drop in light red.

32 Spatter the right-hand foreground with burnt sienna and a touch of cobalt blue using an old toothbrush and a paper mask.

33 Use the no. 3 rigger and burnt sienna and ultramarine to add twigs and other detail to the right-hand foreground. Stand back from the painting and make final adjustments such as strengthening tone or lengthening branches where required.

The finished painting

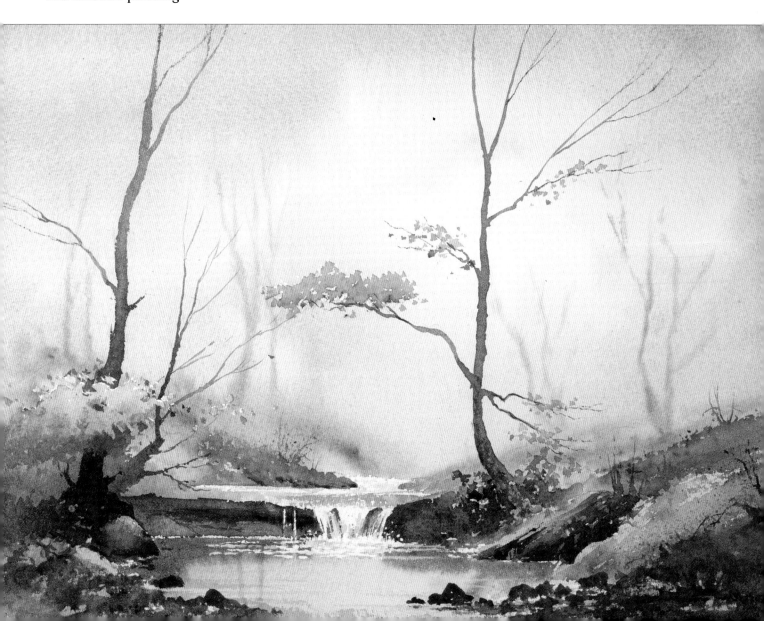

Winter

In this section we look at winter scenes before the coming of snow. If we choose our moment well, we can make the most of strong, low lighting and dramatic skies, and of course, we avoid those masses of summer greens. As the leaves disappear, nature reveals many hidden glories, both natural and man-made: gaps in the trees and vegetation highlight features not visible in summer, such as a sparkling river or lake; a distant crag, or cottages and farms nestling in the landscape.

In winter the fields usually take on a greater variety of colours and textures. The trunks and branches of trees can display interesting and unusual colours, especially when seen as a mass. The striking wine-coloured small branches often seen on birch trees can add warmth and colour contrast to a scene, which is particularly exciting when they are viewed against snow. Dead leaves in trees and hedgerows, and littered on the ground, can be included even when they are not present, as their warm reds enliven the landscape and break up masses of twigs and branches. Ploughed fields introduce a whole variety of colours, tones and textures, varying according to how wet they are with puddles or even floods. The light-coloured stalks of cut crops, if not over-done, can be a joy to paint, especially if you direct the flow of their planting lines to lead towards your focal point. If you are still anchored to green fields, you can still have them, albeit not quite such a warm, vital green as in summer.

Wiltshire Barn
30.5 x 40.5cm (12 x 16in)
300gsm (140lb) Not paper

It can feel quite liberating painting a pastoral landscape without a preponderance of greens, and a versatile colour for winter fields is Naples yellow, slightly modified in places with the stronger yellow ochre or raw umber. Here I added raw umber after the wash of Naples yellow had dried, brushing it horizontally across the lower part of the field, dry-brush style. On the left-hand side, the Naples yellow stands out well against the background hills and trees, which were painted with French ultramarine and cadmium red.

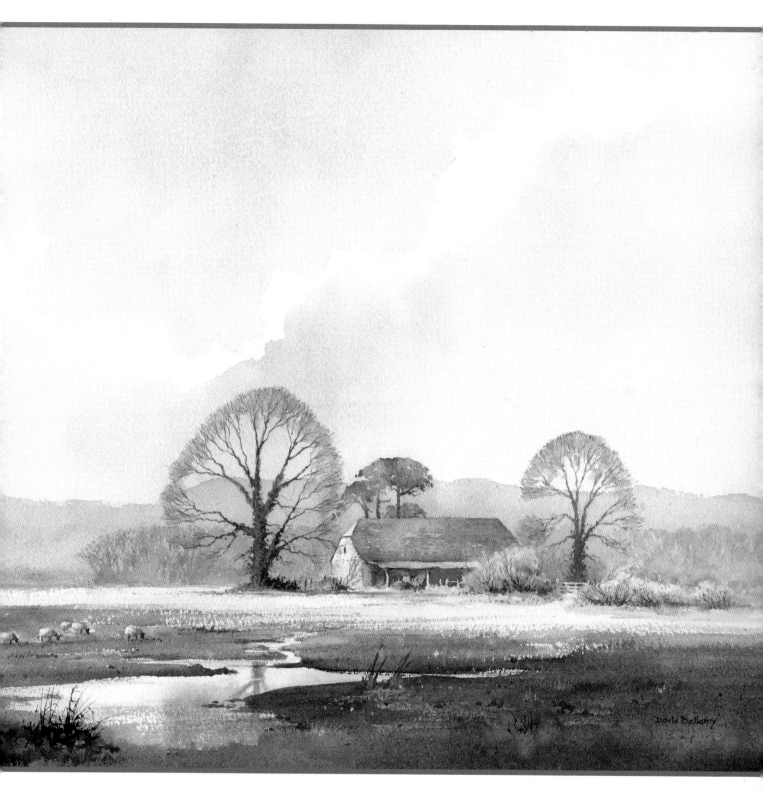

For the barn, I began with an overall wash of Naples yellow, and when this had dried, I laid light red across the roof, allowing the Naples yellow to show through in places. While the light red wash was wet, I added darker parts to the roof with a mixture of light red and French ultramarine, without much water on the brush. This approach created a more rustic, variegated roof. The side roof was painted with cobalt blue, and I created the details below it by painting in the dark negative shapes and adding a splash of cadmium red to draw the eye.

Though the sheep add life, I have kept them subdued in order to avoid conflicting with the barn as a centre of interest. I could have placed them closer to the barn, but then they would have been rather tiny. I included the puddle both to break up the foreground and to lead the eye towards the barn.

33

Rogue colours in the landscape

There are normally far too many colours in the landscape in front of you, and we need to reduce these to impart a greater sense of unity to the scene. I rarely copy the colours before me, preferring to impose my own sense of colour, whether I feel the need for strongly contrasting colours or more harmonious ones. I always try to take into account the adjacent colours, as this has a strong bearing on how we see the whole effect.

One device I constantly use is to drop in what I call 'rogue' colours where I think the composition would benefit. These are often reds or yellows dropped into a wet patch of colour to warm it up. You will see examples of this approach throughout this book. It can be a strong red placed on a prominent tree trunk, a bright yellow field in front of a building, or a patch of Winsor blue amid some warmer blues in a snowy foreground.

Galway Coast
28 x 40.5cm (11 x 16in), 300gsm (140lb) Not

Although there tends to be more colour in the natural landscape in winter, it is often helpful to exaggerate the warm colours, both to draw the eye to a particular part of a composition, and to counter the coldness in a scene. In this painting of the Galway coast in Ireland, I have warmed up the strip of land below the cottage and the right-hand foreground with a rogue cadmium red, to alleviate the overall coldness of the scene and to give more prominence to the focal point.

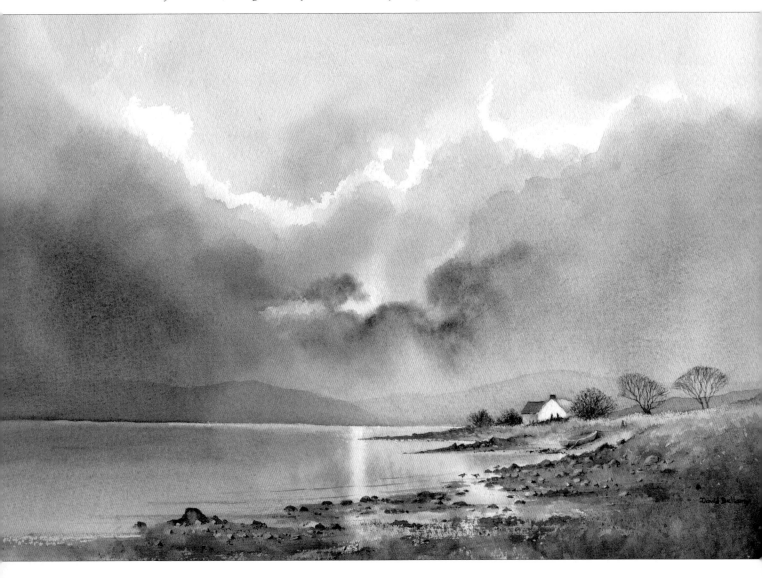

Emphasising warm and cool colours

By juxtaposing warm against cool colours, you will achieve greater impact, for example, where a warm sky makes a snowy landscape appear colder. Here we can see how the cooler passage depicting the water emphasises the warmth in the adjacent bracken.

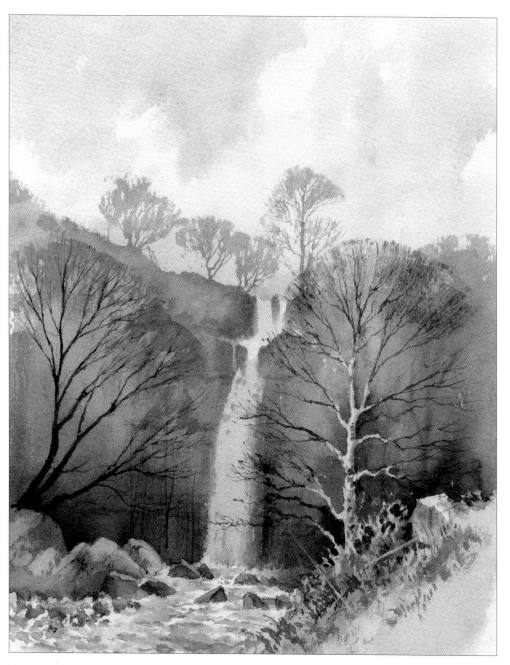

Blaen y Glyn Falls
25.4 x 21.5cm (10 x 8½in) Rough

This painting was done mainly outdoors at this location in Wales, until the light faded and the washes refused to dry in the damp conditions, which meant I had to finish it in the studio. This is fine if you ensure that you have all the visual information necessary to complete the scene. Carrying out a sketch while you wait for the washes to dry is an excellent way of recording information. My aim was to bring out the warm colours of the dead winter vegetation, set against the cool colours of the background falls and stream. I chose this viewpoint, where the waterfall was less prominent, and emphasised the warm-coloured bracken and the birch tree, which I suggested by painting the dark negative shapes around it.

Taking advantage of low lighting

The lower angle of light during winter creates some wonderfully long and evocative cast shadows. This is especially apparent in early morning or evening, so you can create a lovely sense of evening by lengthening your shadows and combining this with warm light. Here we look at how I have suggested winter light in mid-morning.

Farm in Winter Sunlight
28 x 35.5cm (11 x 14in), 300gsm (140lb) Rough

Including cast shadows will really emphasise the feeling of sunlight, so take full advantage of long winter shadows whether they sprawl over a building or field. In this painting the low winter light is coming from the left, throwing shadows from unseen trees across the foreground field. Note that all the fields and hillsides are either pale yellow or pale green – this affords maximum opportunity to make the cast shadows stand out. To accentuate this effect, I sometimes change a dull grey or ochre building into a whitewashed one. I used masking fluid to retain the light cut stalks leading towards the farm. Ruts, furrows and rows of stalks are an excellent way of leading the eye to the focal point.

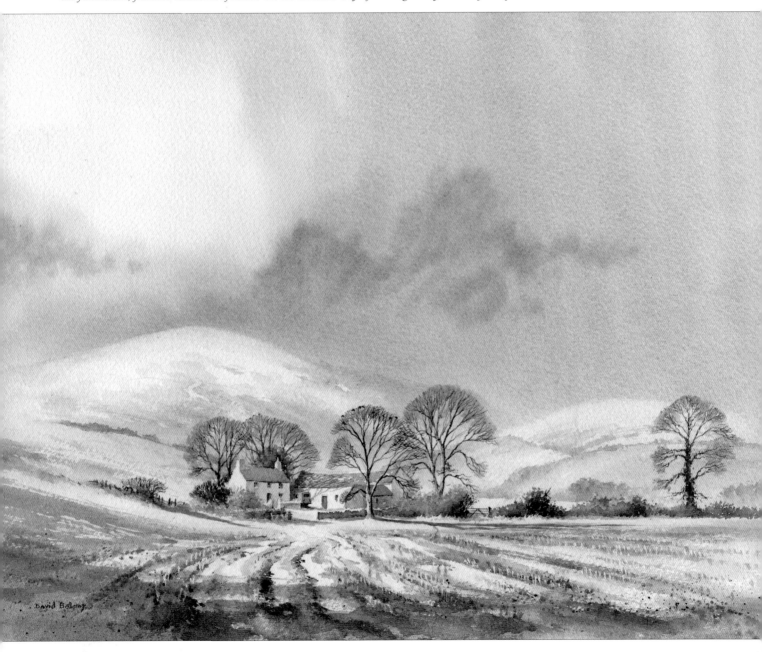

Using spatter

The spatter technique can be extremely effective for adding interest and, because it is less controlled, a sense of spontaneity. It can be used for a confined area such as the extremities of a bush or vegetation, or for a larger spread across a foreground, to suggest roughness. As the spattered blobs can fly off in all directions, you need to mask off areas where you don't want them. An old toothbrush is excellent for creating spatter, but here I show other methods.

Pembrokeshire Farm
20.3 x 28cm (8 x 11in)
300gsm (140lb) Not

In this painting of a farm in Wales, I used a no. 8 round sable brush, charged with a fluid mix of French ultramarine and burnt umber, and I brought the brush down sharply onto the handle of another brush to induce a jolt which spattered the wet paint across the foreground. Sometimes I use more than one colour to spatter an area.

Edge Top Farm, Longnor – watercolour sketch on cartridge paper

I don't normally spatter over snow, but in this watercolour sketch done on the spot in the English Peak District, I felt it would liven things up a little. The character of spatter is greatly affected by the type of brush you employ, the angle of approach, and whether you strike the brush against another object, as in the painting above, or use your finger or a knife to drag through the bristles of the brush. Here I simply loaded a no. 6 round sable with fluid paint, and holding it a couple of inches above the paper, flicked the brush with my first finger, adjusting the angle of the brush and flick of the finger to create a slightly more horizontal trajectory for the left-hand spattering.

Bare branches and trunks

Winter trees and bushes have a charm and attraction that can enhance any landscape painting, and it is worth spending some time studying their characteristics. Tree trunks can be full of exciting and unexpected colours: reds, pinks, yellows, greens and blues, as well as the more common greys. The closer the tree stands, the more scope you have for including colour. Note, too, how branches hang, droop, curve or entwine themselves into amazing contortions. Here we look at a few examples.

Negative tree trunks

An effective method with winter trees and bushes is to create a mass of branches and vegetation, apply negative painting into it to suggest trunks, then bring out the massed branchwork at the top. In this example, I started with a small wash of yellow ochre heightened with a touch of cadmium yellow pale, and immediately dropped in some weak Indian red above this, then a little burnt umber and French ultramarine above that, using the side of a no. 6 brush to suggest a mass of branches and letting all the washes intermingle. This gradual change of colour is a simple but effective technique. When the combined wash had dried, I described more branches with a rigger, over the upper burnt umber and French ultramarine wash. This gave a sense of depth to the branch structure. Finally I painted in the negative shapes between the trunks with a darker version of the French ultramarine and burnt umber mix.

Angular, sweeping or drooping branches

When you paint bare trees, note how the branches form as they leave the trunk: some shoot straight out, while others, such as thorn trees, are extremely angular. Others change direction dramatically or flow downwards in a graceful curve, like larch branches.

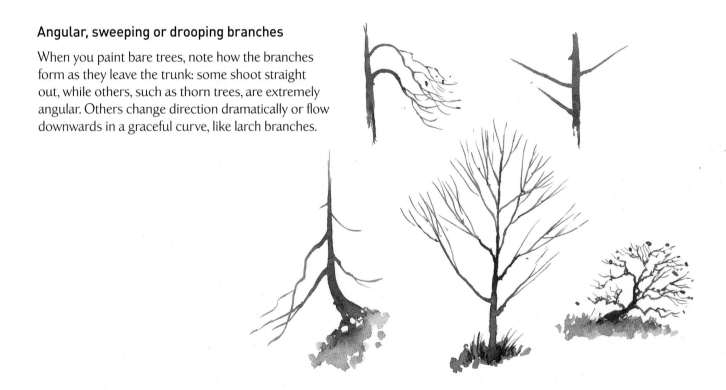

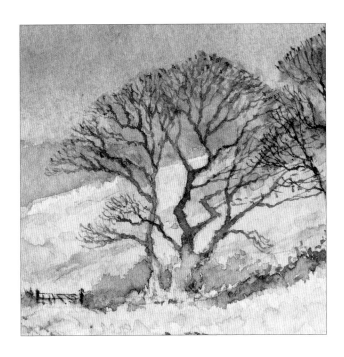

Choosing those special trees

Tree shapes make a fascinating study, and it is of great value to identify really good specimens and sketch and photograph them to keep as a reference for when you need that special tree. Sometimes the sub-branches leave the main branch in one direction only, as is mainly the case on the far left-hand trunk shown.

Colour in mature winter trees

As large, mature trees become closer to the foreground, introduce some colour into the trunks. I usually do this by dropping colours such as light red, yellow ochre or even a green into the still-wet paint of the initially dark trunk. The sense of recession here is created by making the more distant trees smaller, lacking in colour and detail, and in a lighter tone than the foreground tree.

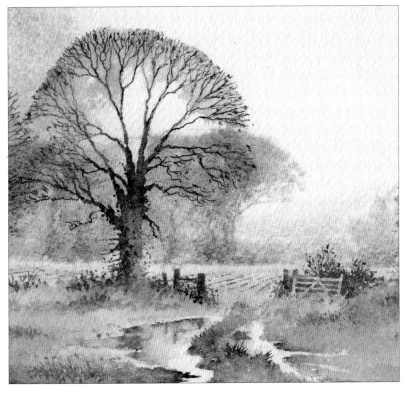

Including figures

The addition of figures into a landscape can boost its impact immeasurably, and is almost vital in town or village scenes. A splash of red is always welcome where colours are muted, but beware of clothing farmers in brightly coloured clothes, as it somehow does not fit their image.

Lavenham Ladies
17.8 x 21.5cm (7 x 8½in) 300gsm (140lb) Not paper

The two main figures draw the eye as the centre of interest, but if you cover them up, the main interest is transferred to the single, much smaller figure, even though he is dressed in drab colours. Don't forget, in winter you need to wrap your figures up well. As I write, it is early February and I have spotted a number of people wandering around in shorts and T-shirts, but to depict them in that way would give the wrong message. Have them doing something or interacting with each other, rather than simply standing around.

Umbrella woman

This figure's stance reveals that she is fighting the wind and it is not a pleasant day. An appropriate stance can really add authenticity to your work.

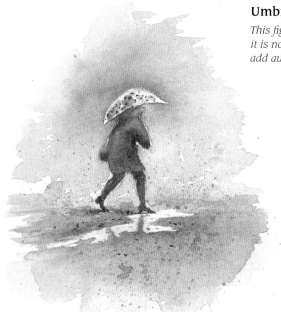

Walking couple

Here the couple are hunched up, huddling together against the elements, and naturally, well wrapped up.

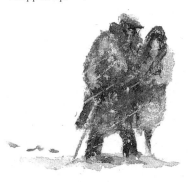

Using birds as focal points

Birds can be included in almost any landscape, sometimes simply to add life to a scene, or even as a focal point if they are prominent enough. Geese, ducks, chickens, pheasants and wildfowl make excellent scene-stealers, whether in flight or on the ground.

Geese Patrol
23 x 30.5cm (9 x 12in)
300gsm (140lb) Not

I often add geese to a farmyard scene, as they stand out clearly and contribute life to a composition. Naturally, white geese stand out best with something dark behind them, preferably plain and uncluttered. These were achieved using masking fluid. Sometimes when you remove the masking fluid, you need to make slight corrections, and for this I normally use white gouache. Any unwanted hard edges left by the masking fluid can be softened with a small flat brush.

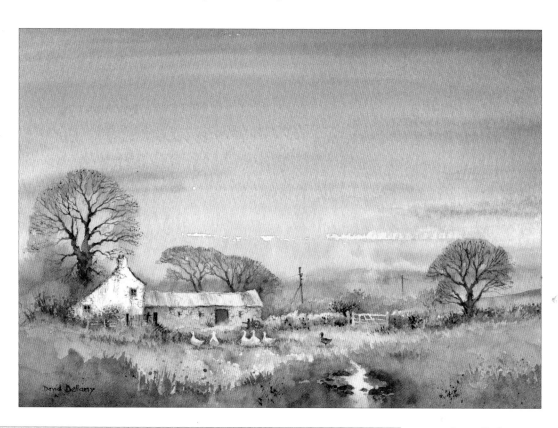

Evening Flight
14 x 23cm (5½ x 9in)
300gsm (140lb) Not

Without the wildfowl, this composition would lack interest. Rendering distant birds in flight does not demand any great skill, but it is worth doing rapid sketches of such moments when the opportunity arises, as they can really help in the case of a pleasant landscape that has no outstanding centre of interest. Photographs often freeze the action of the wings and you can achieve a sense of movement better by observation and quick sketching.

41

Painting light trees against dark skies and backgrounds

Light-coloured trees set against a dark, angry sky or sombre mountain can conjure up real drama, but they are not easy to paint in watercolour. You may be able to see every single branch strongly etched against the darkness, but try to avoid any attempt at putting them all in. Negative painting techniques are almost impossible to render convincingly if you try to emulate a great mass of branches. In these examples I show how masking fluid can work well for this effect.

Light tree against a dark sky

In this example I have resorted to masking fluid for the main branches, applied with a size 0 rigger with most of the masking fluid removed from the brush, so that a fine line was achieved for the outer branches. You have to waste some masking fluid on scrap paper first to check that it is fine enough for your needs. After the dark sky was painted over the light trees, I removed the masking fluid, then scrubbed the top mass of branches with a small, damp, flat brush. This suggests the mass of light twigs and branches. It also leaves a pleasing fuzzy edge to the extremities. I laid a weak glaze of French ultramarine and cadmium red over the right-hand (shadow) side of the tree, and this also helped to prevent it looking like a cut-out.

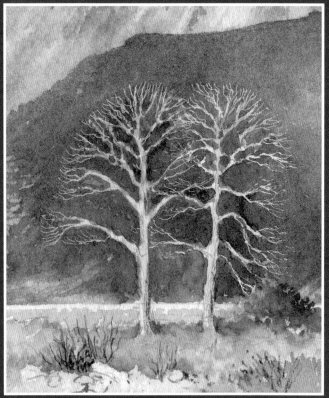

Light trees against a mountainside

In this example, I again used masking fluid for the trunks and main branches, but this time I painted the mass of twigs and smaller branches with white gouache, using a size 0 rigger.

42

Experimenting with a looser approach

Sometimes it is great fun to let go of the control stick and enjoy the spontaneity of the watercolour medium, by laying washes without any preliminary drawing, working into them wet into wet with other colours, and lifting out highlights with tissues or a damp brush. Here I was aiming at creating a marshy landscape, playing with various shapes and tones, and only in the final stage deciding on a centre of interest, which might be a prominent tree or bush, a hut, animal or bird, or whatever struck me at the time.

Experiments like this are invaluable for progressing your paintings, and even if you have to scrap the results at the end, you still learn a great deal.

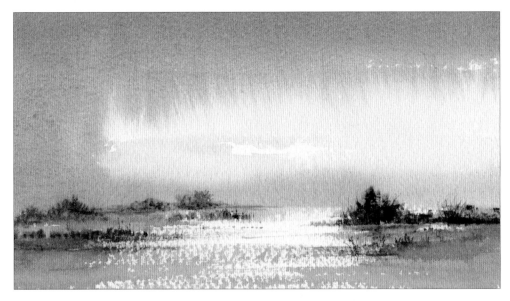

1 I began by laying in the sky washes, with Naples yellow first, then a mixture of cadmium red and French ultramarine above and below the yellow. In places, the purple wash bled downwards, as I was throwing it around with a bit too much panache, but the important point was to retain at least some white paper in both sky and water. Some bushes and clouds were then inserted while the paper was still wet. The burnt sienna on the right-hand bushes was almost straight out of the tube, so it didn't spread very far. This is a useful trick to remember when you want to experiment with the wet-into-wet technique. In the immediate foreground, I laid some weak burnt sienna and French ultramarine, using a squirrel-hair mop and the dry-brush method.

Winter Marshland
14 x 25.4cm (5½ x 10in)
640gsm (300lb) Rough

Once the painting was dry, I intensified the central sky detail with the mixture of cadmium red and ultramarine, wetting the sky above the white area before applying the paint. This created a soft edge to the top of the wash. Finally I had to decide on the focal point – should it be ducks, or perhaps pink flamingoes? As this was supposed to be winter in Britain, I decided on the former, but this more free system of working does give you some interesting options, and is excellent for getting you out of a rut and avoiding too much finicky working.

WINTER MOUNTAINS

In winter, places like Buttermere in the Lake District, UK, are easier to access than in summer, when they can be choked with people and traffic. You don't have to walk far to get a decent viewpoint, and can always retire to the pub if the weather gets too much. In winter the mountainsides can reveal many warm colours, which you can move to suit your composition. A cool-temperature passage or two works wonders for balance and will make your warm areas appear even warmer.

Materials used

Saunders Waterford 640gsm (300lb) Rough watercolour paper

Brushes: Large and small squirrel mops, no. 7 and no. 4 sable round, 13mm (½in) flat, no. 10 sable round, no. 1 rigger

Colours: Naples yellow, yellow ochre, cadmium orange, cobalt blue, French ultramarine, burnt umber, cadmium red, Indian red, light red, quinacridone gold, green gold, raw umber, alizarin crimson

Sponge; paper mask

1 Draw the scene with a 6B pencil. Wash the sky and mountains with a large squirrel mop and clean water, then wash Naples yellow and a little yellow ochre over the area, followed by Naples yellow and cadmium orange on the right. Mix a little of the orange with cobalt blue and wash this diagonally across for cloud.

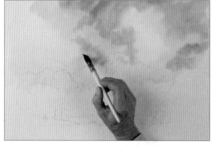

2 Working wet into wet, paint in darker cloud with French ultramarine and burnt umber, leaving hints of white and suggesting cloud boiling up over the mountains. Allow to dry.

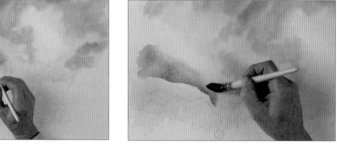

3 Paint the background ridge with pale cobalt blue and yellow ochre, on a fairly dry no. 7 round brush. Use the small mop to rewet the sky behind this and darken it with burnt umber and French ultramarine to highlight the ridge.

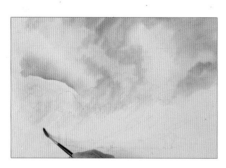

4 Use the no. 7 round and dry-brush work with cobalt blue and yellow ochre to paint the scree on the mountain slopes.

5 Paint the rocky area in the middle ground and foreground with yellow ochre, then paint Naples yellow for the trees on the right, which will be light against a dark background.

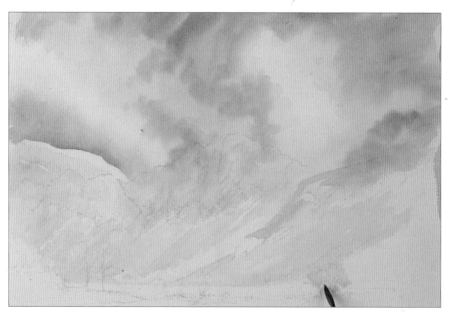

44

6 Use a damp 13mm (½in) flat brush to soften the hard edge of the background ridge, then use a large mop brush to paint water over the left-hand side of the painting and apply a glaze of cobalt blue and cadmium red. Allow to dry.

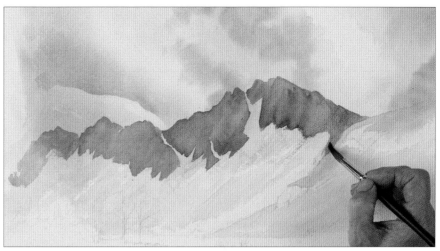

7 Mix light red and ultramarine and use the no. 10 round brush to paint the crags of the mountains wet on dry, then drop in yellow ochre. Continue across the painting in this way.

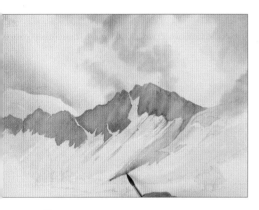

8 Use a paler version of the same mix with a no. 7 brush to paint behind the foreground ridge on the right. Drop in Indian red wet into wet.

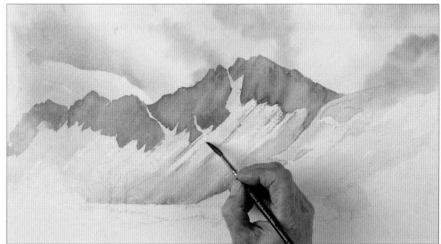

9 Rewet the middle area and drop in light red, then Indian red at the bottom. Allow to dry.

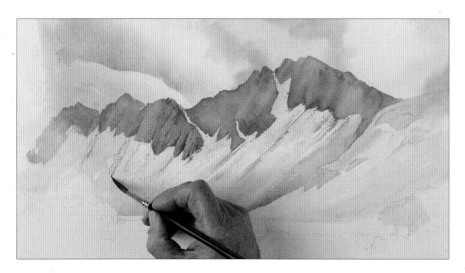

10 Suggest detail on the crags and the lower slopes with the same mix and dry-brush work.

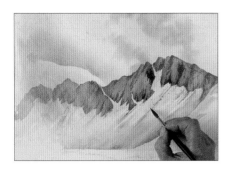 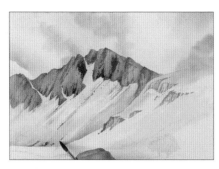 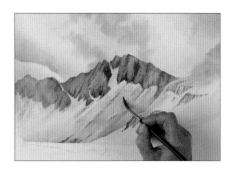

11 Wipe a damp sponge diagonally over the left-hand side of the mountains to subdue them, then use the point of the no. 7 brush to paint detail of the middle crags with French ultramarine and burnt umber.

12 Paint more rocky detail on the right-hand side in the same way, and continue on the lower slopes.

13 Add yellow ochre to the slopes.

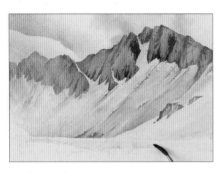 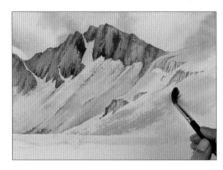 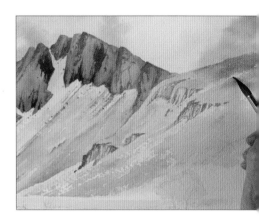

14 Drag a pale mix of cobalt blue across the lake, leaving speckles of white, and allow to dry. This brings out the warmth of the colours behind it.

15 Use the no. 10 brush on its side to paint broken colour across the right-hand slope with light red, then soften the edges with water. Add more yellow ochre.

16 Paint quinacridone gold on the surfaces catching the light to highlight them. Blend in a mix of French ultramarine and light red.

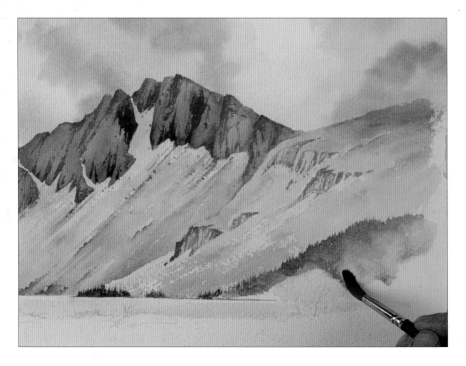

17 Use the no. 7 round and a mix of ultramarine and raw umber to paint conifers on the far shore. Continue them along the lakeside to the right, changing to green gold and cobalt blue. Soften the bottom of the shape with water.

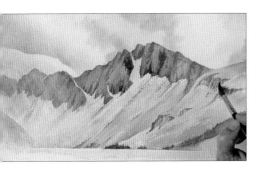

18 Paint a very pale slope of French ultramarine and light red on the far left, then add shadow to the right-hand crags with cadmium red and cobalt blue. Allow to dry.

19 Use the no. 4 round brush and raw umber to paint the area of trees on the left, then use the no. 1 rigger and a mix of burnt umber and French ultramarine to paint trunks and branches.

20 Paint conifers to the left using the point of the no. 7 brush and a mix of raw umber and French ultramarine. Paint round the lighter trees. Drop in quinacridone gold.

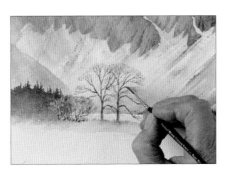

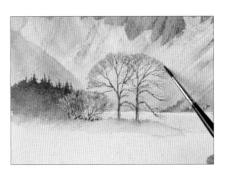

21 Use the same mix and brush to paint the two main trees on the left, then drop in green gold while the trunks are wet. Paint green gold beneath the trees as well.

22 Change to the no. 1 rigger and paint the finer branches with burnt umber and French ultramarine.

23 Use a weaker mix of the same colours and the no. 4 brush on its side to create the twigwork.

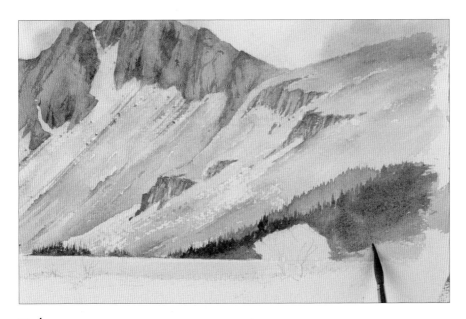

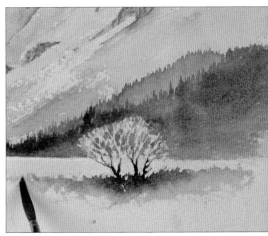

24 Use the no. 7 brush and a green mix of French ultramarine and raw umber to paint the darker conifers on the right-hand lakeside. Paint the pointed tops first, then scrub in the broader area.

25 Suggest the light winter trees against the dark background with negative painting, then paint the trunks and details with French ultramarine and burnt umber. Drop in light red at the base of the trees, then yellow ochre wet into wet.

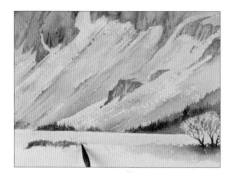

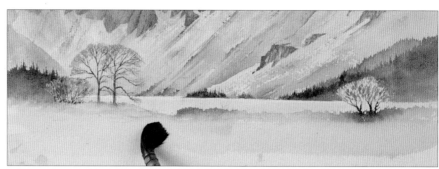

26 Paint the dry-stone wall in the foreground with French ultramarine and raw umber.

27 Use the small squirrel mop to sweep in a wash of yellow ochre in the foreground. Allow to dry.

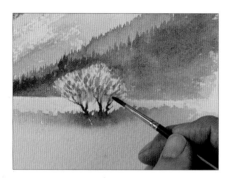

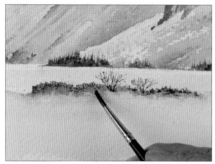

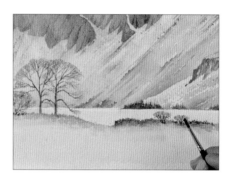

28 Use the no. 4 brush with a pale mix of French ultramarine and a hint of burnt umber to suggest shadow in the lighter trees.

29 Change to the no. 1 rigger and a mix of burnt umber and French ultramarine and suggest bushes against the wall. Hint at stones, especially capstones. Add tone in the wall to subdue the stonework.

30 Darken under the left-hand trees with a little raw umber, then apply alizarin crimson to the bushes for twigwork.

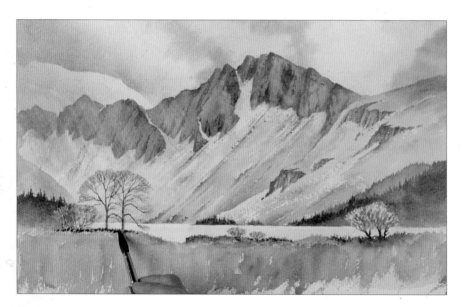

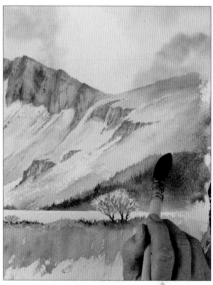

31 Darken the foreground with the no. 10 brush on its side and a mix of cobalt blue and yellow ochre, creating texture. Drop in cadmium red to liven it up, and light red at the edge of the lake. Darken under the trees with French ultramarine and burnt umber.

32 Subdue the right-hand conifers with the small mop brush, first with clean water, then a glaze of cobalt blue and cadmium red.

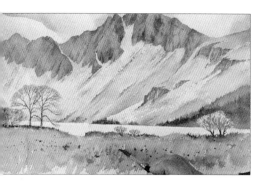

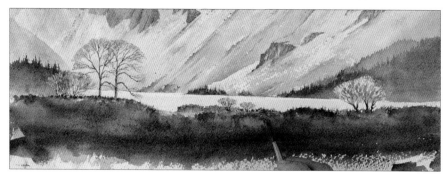

33 Spatter light red and French ultramarine in the foreground from a paintbrush, then drop in more light red and use the no. 7 brush to flick up grasses.

34 At this point I stood back from the painting and decided to darken the foreground. Load the large mop brush with burnt umber and French ultramarine and sweep it over the foreground. Dot suggested detail over the glaze to reinstate it and drop in Naples yellow and light red. Spatter some water across the damp wash to add texture.

The finished painting

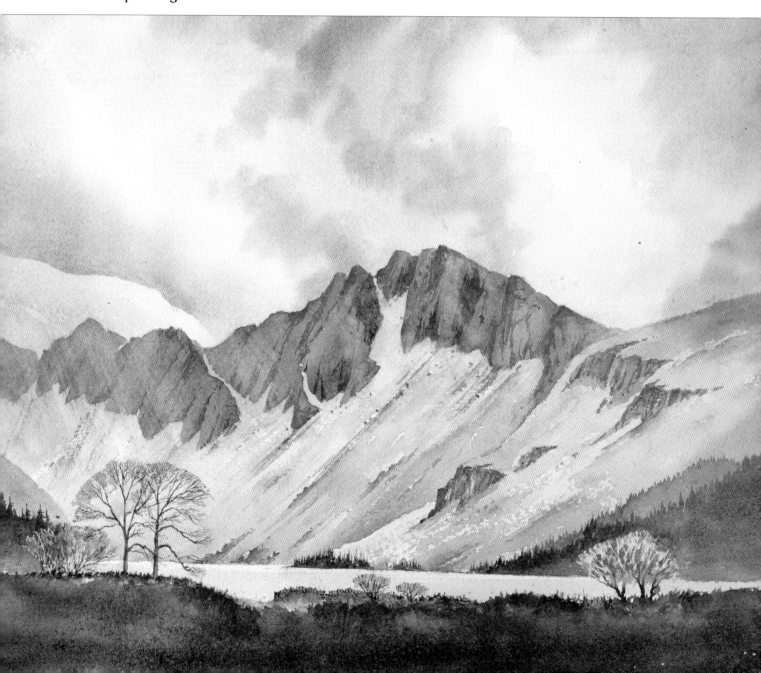

Deep mid-winter

A fall of snow, even a light covering, brings a complete change in the landscape. Everything appears fresh and clean, and landscape features stand out more clearly against the whiteness. In watercolour, we use the white of the paper to suggest snow, and exploit the reflective properties of snow by tinting it with colours. Here, more than ever, we need to keep our washes clean and avoid muddying the painting.

Snowy landscapes vary considerably, depending on the thickness of the snow, how much it has melted, and how long it has been there. Deep, fresh snow presents a different effect to a thin, patchy covering, or snow that has fallen off trees and roofs and been cleared off roads. Once you are experienced at observing these various states of snow cover, you can alter those elements in the scene to your advantage: you may not wish to have every branch covered in a stark whiteness, or you may like to suggest tracks, human, animal or vehicle, in the snow. One of the most striking features of snow appears where it has melted apart from in long gullies descending a mountainside, creating a zebra-skin impression.

Snow sometimes remains only briefly, so it is important to capture the spectacle as quickly as possible. Get out and record the scenes as soon as you can, as it changes throughout the day. Note how it appears at different times of the day, and especially when bathed in sunshine and thus more susceptible to reflected light. As dusk approaches on a clear day, a snow-covered landscape can exude a lovely atmosphere. In this chapter we shall look at how to tackle scenery under a blanket of snow and consider the exciting opportunities afforded by this striking transition of our landscapes.

The Roaches Under Snow
20.3 x 30.5cm (8 x 12in), 300gsm (140lb) Rough

This was painted outside on a beautiful, sunny day when deep snow covered the moorland in the Peak District, UK, and the temperature hovered around freezing level. Clad in an Arctic jacket, thermal vest, woolly hat and thick snow-boots, I sat in a picnic chair in supreme comfort. With barely any wind, conditions were excellent for working in watercolour, though you will just see a hint of patterns in the sky caused by slight freezing of the more moist parts of the wash. For this I used a block of Saunders Waterford Rough 300gsm (140lb) paper, which is convenient for working outdoors.

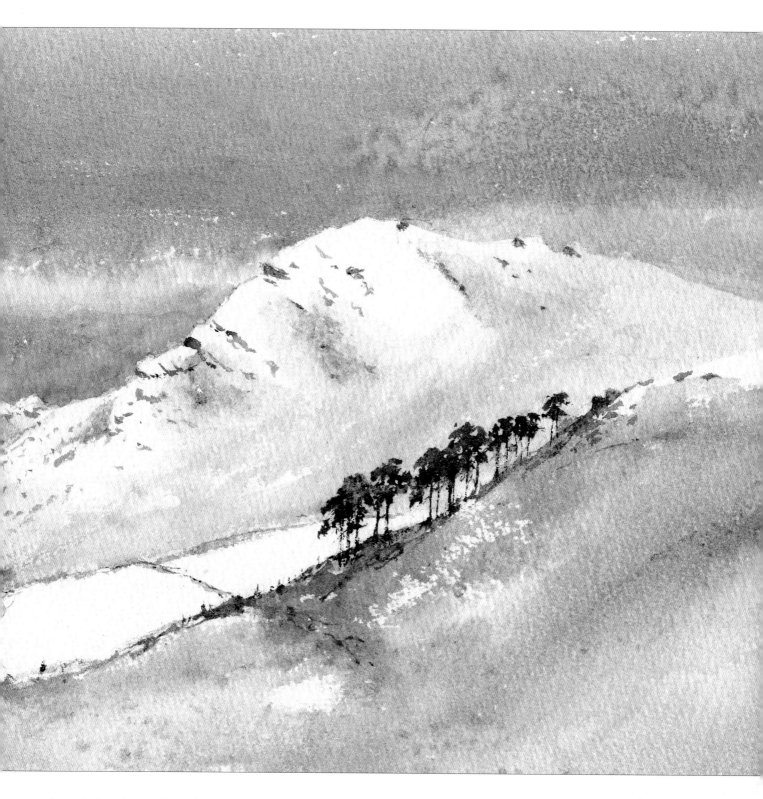

I began by bringing the sky wash down to define the tops covered in snow. These were left as untouched white paper, but I brought in some shadow areas lower down. Having it all stark white results in a rather boring composition, and anyway it was changing all the time with passing cloud shadows. The temptation to insert a lot of rock shadow detail was great, but I subdued the urge and just suggested a few. The detail is angled diagonally from top left to bottom right, and this also suggests the slope of the hill. The row of Caledonian pines made an excellent centre of interest, and I emphasised the redness on the ground beneath them to further draw the eye towards them. This was caused by bracken sticking up through the snow. Make use of this colour effect in your snow scenes, as it is an effective tool for creating variation and interest.

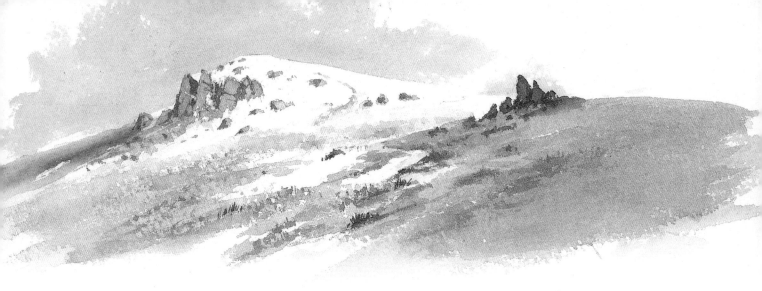

Snow cover

Snow cover can vary considerably from thin, patchy effects to deep snow obliterating almost everything, and the transition from snow-covered hills to the bare ground can cause painters problems. By studying these varied effects, you will be in a better position to alter a scene to your advantage, so when you encounter the next fall of snow, consider how you can render these effects to make the most of the changed landscape.

Transition from snow

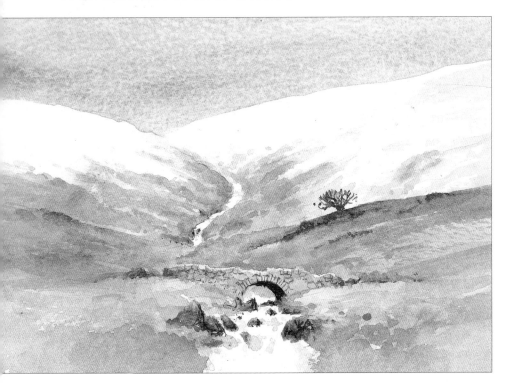

Thin, patchy snow on open moorland

A thin layer of snow gives you the opportunity to place your whites and other snow colours were they work best for you, as well as laying in the warmer colours of the bare ground to best advantage. Don't have too many fiddly little patches of snow, though, as it will look messy. In this example, you will see both hard and soft transitions between snow and untouched ground, and note the winding path which is white in the foreground where snow has accumulated, and dark as it crests the upper slope in the snow. The light red has been applied with a dry brush, blending in some of the edges with a damp brush. It's amazing what magic you can find in such a simple scene, just by spending a few minutes observing the land.

Bridge scene

Painting a snow-covered background of hills and mountains, while retaining a snow-free foreground, can be an attractive way of working. It does not have to be all snow, and sometimes when snow has melted, foregrounds can appear really messy. The transition from snowy areas can be achieved in different ways. On the right, you will see how a dark ridge, painted with light red and burnt umber, stands out hard against the snow background, while on the left, the transition is more gradual. For this latter effect, you can wet the paper first and then take the ground colour up into the wet area – yellow ochre in this case, tinged in places with a mid-grey made up of cobalt blue and light red. An alternative method is to paint on to dry paper with the side of your brush, or simply to brush upwards with a dry brush, as in the craggy moorland sketch above.

Using a candle resist

Another technique for representing intermittent snow cover is to drag a candle across the required part of the painting, as in this Dartmoor scene. The wax will resist watercolour washes.

Vibrant colours in the snow – Herefordshire Lane

15.2 x 20.3cm (6 x 8in), 640gsm (300lb) Not

Foregrounds are rarely easy, and often snowy ones can appear almost devoid of any detail, so that we may be tempted to paint in all manner of vegetation sticking out of the blank whiteness. One method I enjoy is splashing in a number of colours – usually different blues, but sometimes even a red, despite it being quite the opposite to anything present in the scene. In this small watercolour, I have added some Winsor blue and permanent rose to join the wash of French ultramarine and cadmium red. The white trees were achieved with masking fluid, with some of the branches washed over after the mask was removed, to create more shadowy branches.

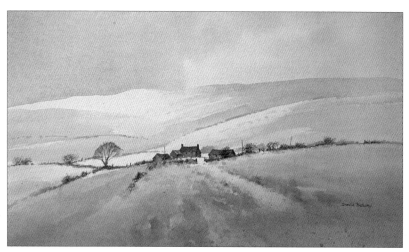

Moorland Farm

In this composition, you can see various tones on the snow-covered fields, and in particular the change of tone where the hills meet the sky: the hill is simply white paper against a dark sky on the left, and blue-grey against a lighter sky on the right. Planning this out before you start painting will reap excellent rewards. Note how the hedgerows are not continuous. Rather than paint in detailed vegetation sticking out of the foreground snow, I have simply splashed in patches of yellow ochre in a few places, a useful alternative to over-detailing this rather vulnerable part of a painting.

Landscape under deep snow

This scene in North Staffordshire, UK, immediately appealed: deep snow simplified the composition, the road formed an excellent lead-in to the centre of interest, and strong afternoon sunlight created interesting cast shadows and highlights.

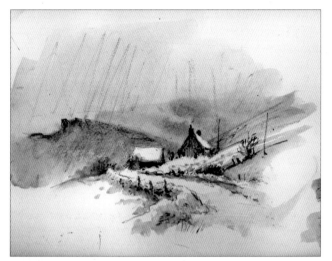

The actual scene was almost a monochrome and could well have been painted as such. At times, winter presents us with a monochrome, so take advantage of these interesting situations, which can exude a powerful sense of mood.

Colour sketch

With an indigo water-soluble ink block, I drew in the main features, then applied tone in varying strengths, before washing over the sketch with a wet brush. This is a quick way of producing a sketch and the water-soluble ink block encourages you to avoid describing too much detail.

Farm at Flash Bottom
25.4 x 15.2cm (10 x 6in)
Rough

The lower sky and distant hills were painted with washes of French ultramarine and cadmium red, with the far ridge appearing and disappearing in places. The white parts were left as untouched paper. I added a red muck spreader beside the farmhouse for interest and colour, and the cast shadows gave a strong feeling of sunlight. Blobs of phthalo blue in the foreground create additional variation.

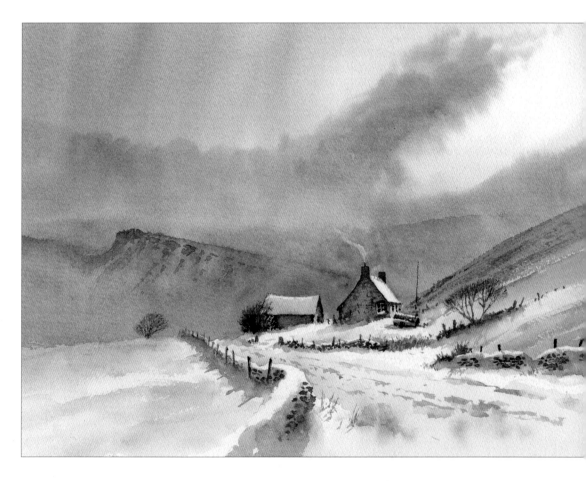

Creating detailed white areas

Normally I prefer to retain small detailed white areas using the negative painting technique:
I paint the darker part of a feature around where I want the white part to show, which is left
as white paper. In certain cases, I use masking fluid. Many artists find the negative method a
little difficult, at least until they have acquired more experience, and masking fluid can often
produce clumsy results. An alternative is to use white paint, and for this white gouache is
excellent as it has great covering power – much better than the watercolour Chinese white.
Some people prefer a white acrylic paint.

 White gouache, however, can look messy when used with watercolour, and I use it sparingly
for extremely small features such as seagulls, distant masts and tiny blobs of light. I do,
however, use larger amounts on tinted papers where it is essential for the highlights, and you
may wish to try this technique for painting on white paper. You can find examples of how I
have used negative painting on pages 35 and 38 and elsewhere. Also, compare this scene
with *Herefordshire Lane* on page 53, where I have used masking fluid. Many artists now use
copious amounts of white in their watercolours, and I show this technique in this example,
but it is not my normal practice.

The Old School in Winter Sunlight
15.2 x 19cm (6 x 7½in), 640gsm (140lb) Rough

*This was painted in the normal way, reserving the application of white gouache until the very
end, as gouache can affect normal watercolours badly where they are partly overlaid. I applied
the gouache thickly with a painting knife and then painted a few branches with it, using a
rigger. Note that if you apply it using impasto techniques in this way, it is best to use a heavy
watercolour paper.*

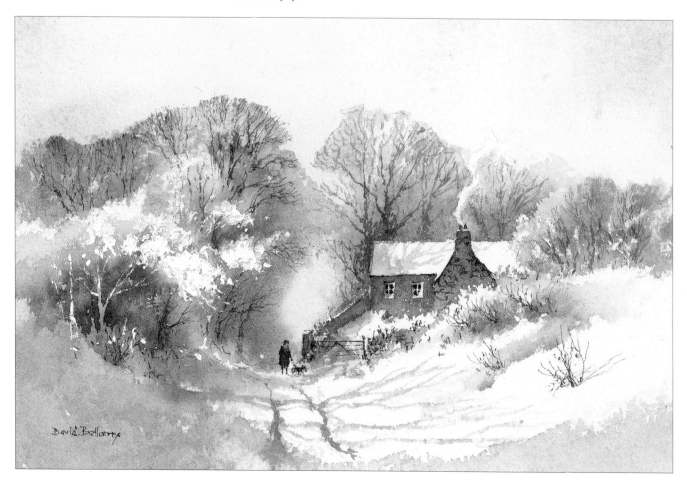

Introducing colour to snow scenes

Unless you are intent on portraying a thoroughly cold environment, totally devoid of any hint of warmth, it makes for a more attractive composition if you introduce an element of warm colour into a snow scene. This can be achieved by painting the sky in warm colours, creating warm-coloured reflections in water, ice or snow, or introducing warm-coloured vegetation, figures or objects. Even a small splash of bright colour can make a difference.

Yorkshire Barn
20.3 x 28cm (8 x 11in)

Snow scenes can appear really cold and uninviting if there is a lack of warm colour. In this landscape, the warm colours in the sky, barn, dry-stone walls and smattering of vegetation all add up to a more welcoming snow scene. I deliberately took some time to work out the sort of sky I wanted, and where to place the warm colours. A studio sketch carried out in colour will help you work this out.

Massed trees and snow

A subtle way of increasing the warmer feeling of your snow scenes is by mixing or dropping in warmer colours instead of perhaps more neutral ones. In this landscape, I have dropped light red into the lower half of the massed trees to give it a lovely warm sensation, instead of using a colour like burnt umber to create a cooler, greyer overall effect.

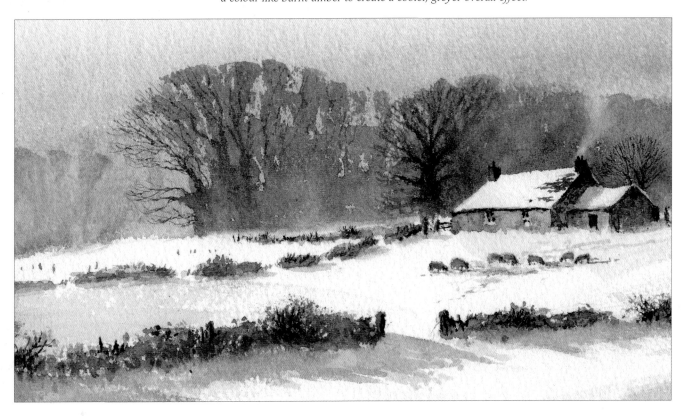

Depicting snow and ice on trees

Ice patterns and snow on trees can range from the ordinary to the spectacular, and they can be further enhanced by the surrounding atmosphere and light. Sometimes the effect of ice-rimed branches can be so overwhelming that any attempt to render such intricate, icy detail will look overworked. Aim for brief glimpses of stunning detail in a lost-and-found manner, and use colour and tone as a substitute for detail in places.

1 At this first stage, masking fluid was applied to the top branches of the birch trees. I then laid a fluid wash of Naples yellow on the right-hand part of the sky, then a mixture of French ultramarine and cadmium red over most of the sky. A stronger mix of the same colours, applied wet into wet, suggested the more distant tree mass, then a very strong mixture was applied with a fine rigger to draw in the main trunks. When the paper had completely dried, the masking fluid was removed.

Snow, Ice and Mist on the Wye
23 x 30.5cm (9 x 12in) 300gsm (140lb) Not

I painted more Naples yellow onto the main trees to suggest a slight warming of colour temperature, then the shadow areas with French ultramarine and cadmium red. Yellow ochre was laid over the reeds and vegetation. For the river, after wetting the whole area with clean water, I painted weak Naples yellow in the centre, suggesting some colour reflection from the sky. I then added French ultramarine and burnt umber, running it into the Naples yellow. A light patch of ice was created on the left by working negatively round the shape.

Once everything was dry, I re-wetted the river on the left and applied a strong wash of ultramarine and cadmium red into the darkest reflections, thus highlighting the reflections of the lighter snow-covered bank. Finally I scratched out slivers of light with a scalpel.

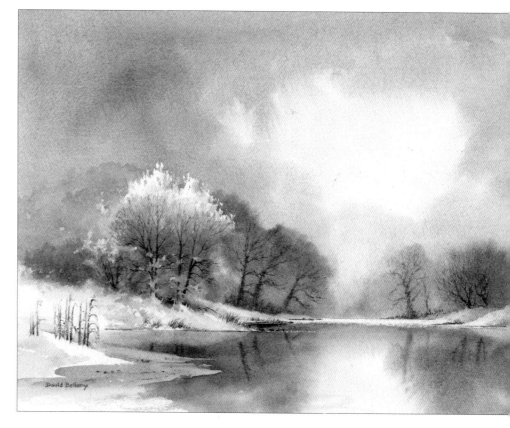

Capturing a castle in watercolour

On this occasion the atmosphere was constantly changing and the washes slow to dry, so outdoor watercolour sketching was challenging, with the great temptation to change my response as conditions altered. That can be fatal to a work, so either do a second sketch or take several photographs as things change.

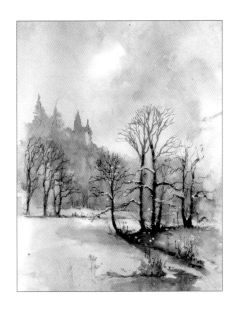

This viewpoint appealed to me, as the building rose above the trees, all in sunlight apart from the foreground. For this watercolour sketch, I drew into the wet washes with a black watercolour pencil to speed things up. Even so, the sketch took a long time in slow drying conditions, and by the time I had completed it, the sun had disappeared and ground mist created a magical, ethereal atmosphere. In the resulting painting, I decided to incorporate both the sun on the castle and higher trees, and the mist lower down.

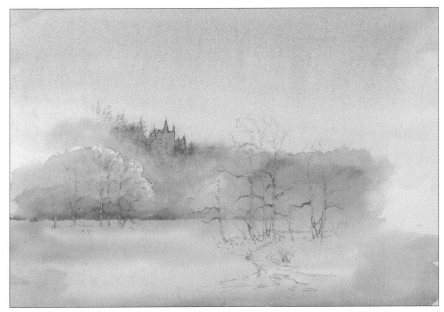

1 I began by laying a wash of cobalt blue over the upper sky, and yellow ochre over the lower part, bringing it down over the trees near the castle. While this was wet, I touched in some weak light red, then allowed it to dry. I painted on masking fluid with an old size 0 rigger for the snow-clad branches, then laid Winsor blue over the lower part of the composition to create a cool effect, though adding in some light red over the left-hand tree mass.

2 I concentrated on the left-hand trees by drawing in the trunks and branches with a mixture of Winsor blue and light red. When this had dried, I removed the masking fluid just from this area, then laid a weak glaze of Winsor blue across the lower section of the left-hand trees.

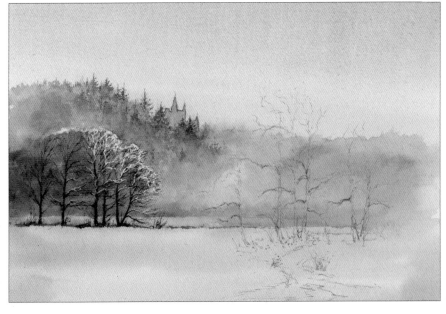

58

Alton Castle, Staffordshire

20.3 x 28cm (8 x 11in), 300gsm (140lb) Not

With the paper completely dry, I sponged horizontally across the lower part of the left-hand trees to suggest mist, using a soft natural sponge and clean water and dabbing off the excess liquid afterwards. This combination of glazes and sponging is effective for suggesting mist. I then created a shadow band horizontally across the picture, below the band created for the mist, with a weak mixture of Winsor blue and light red. The right-hand tree trunks were rendered with a stronger combination of Winsor blue and burnt umber, followed by a weaker mix of the same colours over the right-hand foreground. To suggest the varied tones in the icy water, I used the same mixture in various degrees of strength. Finally I put in the foreground shadows and vegetation.

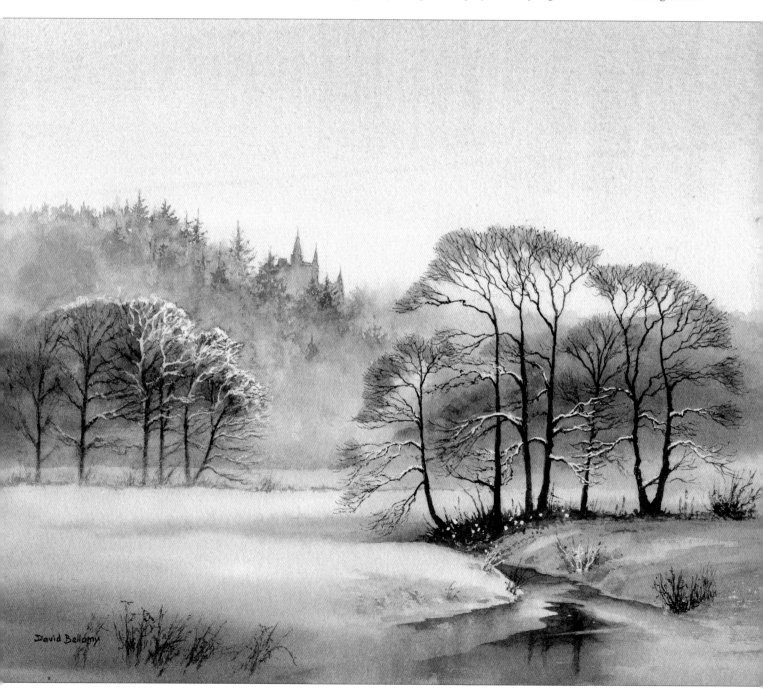

Animals in cold conditions

There is something very appealing and heart-tugging about animals caught in cold snowscapes. Like humans, they often hold themselves in such a way as to show they are suffering from the cold.

Highland Deer
15.2 x 20.3cm (6 x 8in), 300gsm (140lb) Rough

Most artists enjoy trying new techniques. Occasionally, when the subject seems right, I use plastic food wrap to create interesting patterns. This works especially well with snow and ice scenes. Here I applied fluid washes of Winsor blue, at the same time leaving patches of untouched paper to suggest the snow highlights. While this lay wet on the paper, I placed a sheet of plastic food wrap over it and dragged it slightly to the left to suggest a sense of direction. I then left the food wrap in place and allowed the wash to dry. After the paper had completely dried, I removed the food wrap and then painted in the rest of the scene as normal. Sometimes I refrain from doing any pencil drawing until after the washes have dried, thus allowing me to take advantage of how the plastic food wrap has affected the paper.

Cattle Feeding
17.8 x 25.4cm (7 x 10in),
300gsm (140lb) Not

Animals make excellent centres of interest, their appeal accentuated when set in a bleak landscape. Note in this work how background features have been deliberately managed to make the animals stand out. The black Friesians to the rear are silhouetted against a purple-grey hedgerow, totally lacking in detail, while the right-hand beast has a light-coloured back that is clearly etched against the dark bush.

Falling snow

Gently falling snow can be attractive, and is fairly easy to accomplish. Blizzards on the other hand are not so easy. Blizzard effects can vary from the hard-driven type to those where occasional, gentler eddies and flurries of snow stand against a background of indefinite images. It is fascinating to experiment with these effects.

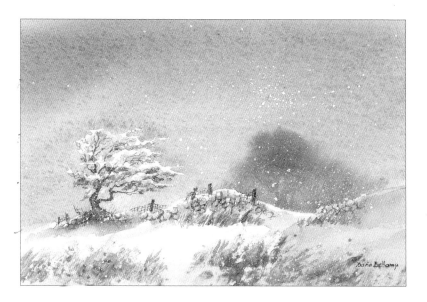

Wall and Tree
12.7 x 20.3cm (5 x 8in)
425gsm (200lb) Rough

The snow on top of the dry-stone wall and on the main tree was accomplished with masking fluid before applying the darker sky wash and then the background trees suggested with a still darker tone while the paint was still wet. The wall, tree, fenceposts and foreground grasses were all added before I spattered white gouache over the painting with a toothbrush, to suggest gently falling snowflakes.

Blizzard in Glen Feshie, Scottish Highlands
20.3 x 25.4cm (8 x 10in) 640gsm (300lb) Rough

I began with a wash of water over the sky, then applied Naples yellow above where the trees would appear. To this I added a weak wash of cadmium orange to warm the sky slightly. A strong mixture of burnt umber and indigo was then laid across most of the sky apart from the area left light, making the right-hand side slightly darker. I waited for a few moments before suggesting some of the pine trees, in two stages to give depth. I waited a further few minutes until the degree of dryness seemed right, then applied the stronger, slightly warmer mixture of burnt umber and indigo to define the main mass of pines.

When the right-hand side of the sky was at the right stage of drying, I used a damp 13mm (½in) flat brush without any colour, with short, energetic diagonal strokes, to suggest the violent movement of the blizzard across the sky and pines. I then picked up some white gouache to strike across the damp paper. Note that you need to use a 'thin' flat brush for this. When the paper was dry, I spattered it with white gouache on a toothbrush, at a low angle, first using a wettish application for the fainter, falling snow, then gouache straight out of the tube for closer snowflakes, to create depth. I then streaked the flat brush through some of the snowflakes in the same direction.

The sheep were rendered in a similar manner, although at the very end I scratched diagonally across them with a scalpel to give the impression of fast-driven snow.

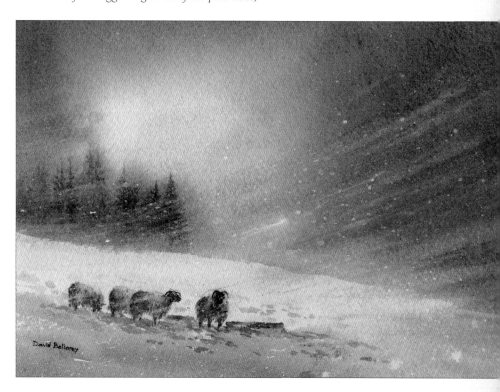

Altering the subject

It is rare to come across the perfect scene as it should be painted, and here I show how I approach the process of making slight alterations to enhance the finished painting.

While this made a superb subject to paint, like so many woodland scenes, the photograph suffered from a dark and dismal mood, being enclosed by tall trees. My aim was to create more space and depth, change the lighting, convey a much warmer impression and improve the atmosphere. While I intended to retain the basic composition, I carried out a studio sketch (below) to clear a number of points in my mind. My changes mainly involved a different choice of colours and tonal values, plus a few minor adjustments to features, rather than major compositional alterations.

Studio sketch

I often add notes as reminders to myself, but here I have included them mainly to show my conclusions on how I would proceed. Exchanging the left-hand trees for a smaller bush, lowering the ground to the left of the bridge so that it does not coincide with the parapet, and reducing the height of the right-hand trees helped to avoid awkward relationships, but more importantly, I felt the bridge needed to stand out more by lightening the far bank viewed through the arch of the structure.

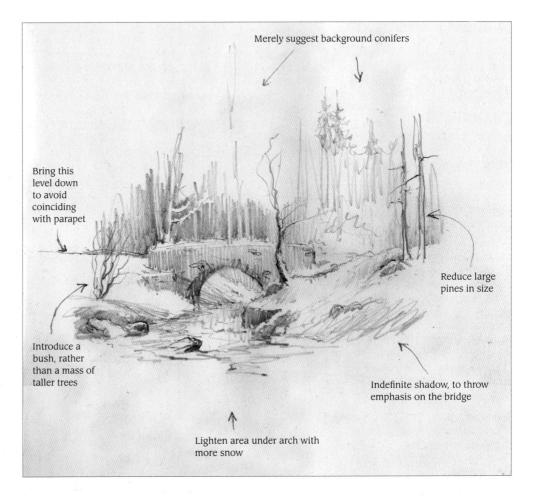

Merely suggest background conifers

Bring this level down to avoid coinciding with parapet

Reduce large pines in size

Introduce a bush, rather than a mass of taller trees

Indefinite shadow, to throw emphasis on the bridge

Lighten area under arch with more snow

Woodland Bridge
17.8 x 25.4cm (7 x 10in), 300gsm (140lb) Not

My first decision was to change the direction of the light source from right to left, so that the front of the bridge would be lighter, and weak cast shadows could be placed for the bridge's left-hand supporting buttress and the tree in front of the structure. Before applying paint, I covered the parapet of the bridge, some of the tops of the boulders, and the main tree branches with masking fluid to retain the intricate whites. I suggested a misty background by inserting the conifers on either side of the central mass with a wet-into-wet application of cobalt blue and cadmium red. This achieved a greater sense of space and depth. I took this wash right across to the right-hand side of the composition, weakening it as I went, and then cooled it with weak Winsor blue. This threw more warmth into the centre of the work.

When the paper had dried, I painted in the central background mass of trees in a stronger tone, thus pushing the conifers I had already painted into the distance. For the bridge itself, I used the cobalt blue plus cadmium red mixture, but dropped a little yellow ochre and some light red into the wash before it dried. Built of old red sandstone, the bridge does reveal a lot of red, especially in sunlight. When it had dried, I suggested a few of the stones with a fine rigger, putting more emphasis on the stones around the arch of the bridge.

I reduced the tree and rock detail and simplified the ground area, especially in the left-hand foreground. A very weak wash of Winsor blue was washed across the river and allowed to dry thoroughly before a second, much deeper wash of the same colour was applied, leaving some of the first wash to show through as streaks across the water. While this second wash remained wet, an even darker application was placed under the bridge to hint at a dark reflection. In a running current, reflections generally do not need to be highly accurate. I painted in the foreground ripples with the same dark colour, using a no. 6 round brush. Finally I removed the masking fluid and spotted in a few flecks of white gouache to indicate snow on the branches.

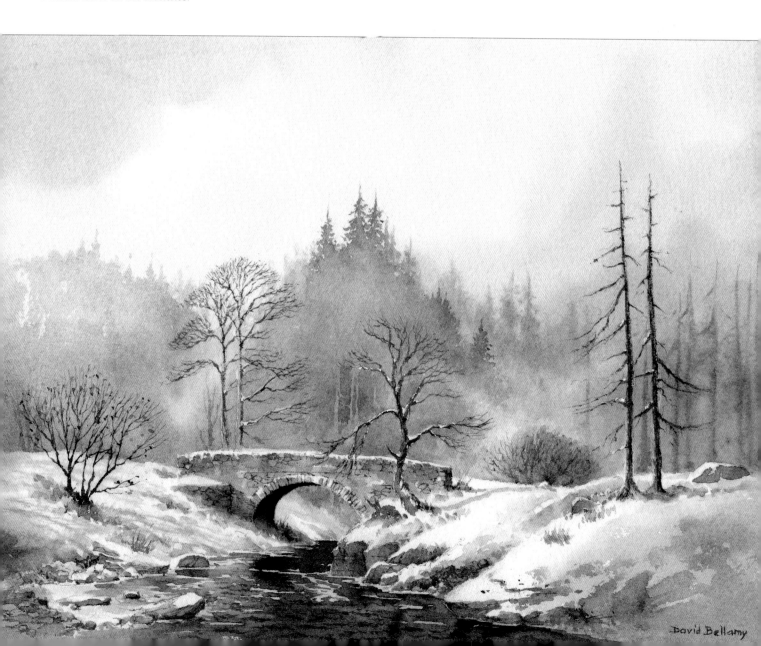

Winter woodland using wet-into-wet method

The combination of the wet-into-wet technique with masking fluid is an effective way of creating a misty background with light, hard-edged features closer to the foreground, and can be used in many situations. Here I use the method to paint a misty woodland scene in deep snow conditions.

Hawksmoor Woodland, Staffordshire, UK
14 x 17.8cm (5½ x 7in), 640gsm (300lb) Rough

Before painting, I laid masking fluid on some of the branches and vegetation where I wished to suggest snow, then washed on some Naples yellow around the centre of the sky area, leaving a patch of white in the very centre. Having already mixed up some cobalt blue with a touch of cadmium red, I drifted this into the outer edge of the yellow and allowed it to blend in. After a few moments, I laid in a mixture of French ultramarine and Indian red with a touch of burnt umber, and painted this on either side and over the top of the light central part. I then waited for it to dry out a little until it was just moist.

When I judged the moment was right, I applied a stronger mixture of French ultramarine and Indian red with a fine rigger, drawing the tree trunks into the damp wash and thus creating soft, misty effects. With a no. 10 round sable and the same mixture, I dabbed in the darker aspects of the lower parts of the trees and then began working on the foreground with the same mix. When the work had dried, I removed the masking fluid, and with a really dark mixture of French ultramarine and Indian red, I put in the stronger tones for the closer branches and left-hand trunks. I finished with a few blobs of light red to suggest dead leaves in the foreground.

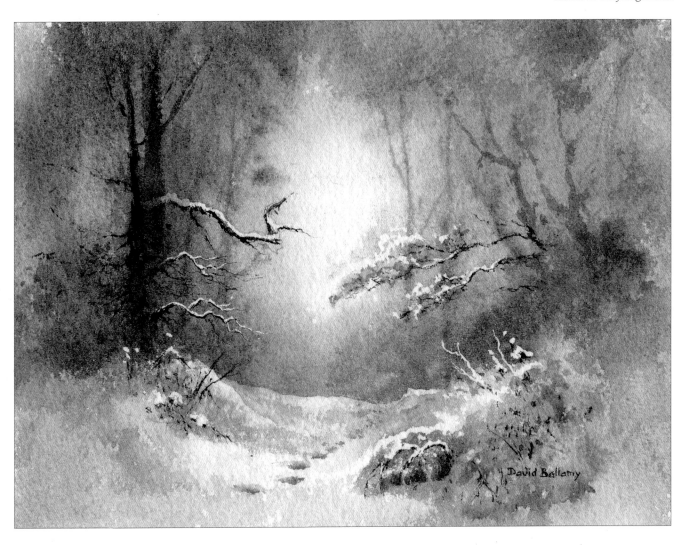

Adjusting the colour temperature

There are times when you reach the end of a painting and you can clearly see that the overall effect is too cold and uninviting. All is not lost, as you can introduce a warm transparent glaze over the whole or part of the work. Make sure the painting is completely dry – leave it overnight if you wish – and then decide where you will apply the glaze. You may decide to cover the whole painting. Permanent rose, quinacridone red and permanent alizarin crimson are excellent transparent colours which will warm up a painting. Mix up a generous pool of colour – quite a bit more than you estimate you will require, as there is nothing worse than having to stop and mix more paint in the middle of a large wash. Test the glaze over part of a watercolour that you will not need any more, and when you are satisfied, lay it over the painting with a large soft-haired mop brush. As with normal washes, you may wish to graduate the glaze by adding more water to the mixture in places.

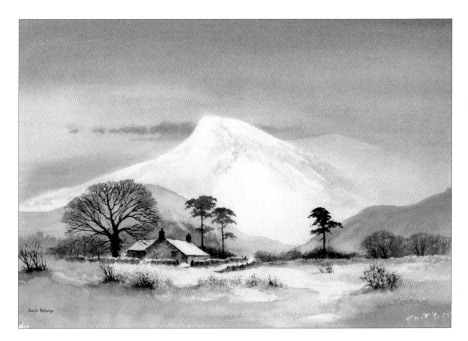

Mountain Farm – first version

This painting was originally done as a demonstration, and when I looked at it some time later, it struck me that it appeared rather cold, and the central part was glaringly white between the Caledonian pines.

Mountain Farm – second version

30.5 x 38cm (12 x 15in), 640gsm (300lb) Not

With a very fluid wash of French ultramarine and alizarin crimson, I glazed the sky and lower mountain passages to suggest an evening scene, with the alizarin crimson warming up the composition considerably. I also strengthened the lower hills and accentuated the smoke rising from the farmhouse. The foreground snow bank also needed darkening to be in keeping with the time of day. This method not only warms the scene but can also suggest reflected colours on a passage of snow.

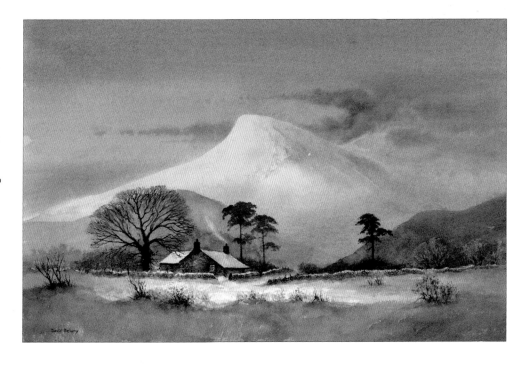

65

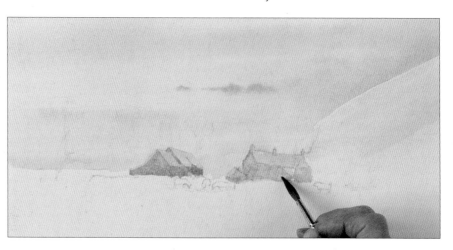

FARM IN SNOW

Intricate white details in a snow painting can be tricky to achieve, and this is where masking fluid really comes into its own, although it often needs tidying up a bit after removal, especially if it has been applied clumsily. In this demonstration, I show how the white features are created, including the usefulness of having a tube of white gouache handy.

Materials used

Saunders Waterford 640gsm (300lb) HP watercolour paper

Brushes: No. 10 sable round, large and small squirrel mops, no. 7 sable round, 13mm (½in) flat, no. 1 rigger, no. 4 and no. 3 sable round

Colours: Cobalt blue, cadmium red, Naples yellow, cadmium orange, alizarin crimson, burnt sienna, Indian red, burnt umber, yellow ochre, cadmium yellow pale, white gouache

Masking fluid and old brush

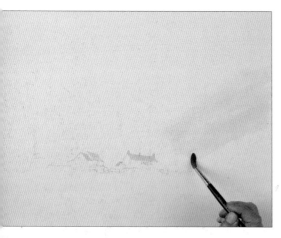

1 Draw the scene and mask the roofs and tops of walls with masking fluid. Add a few dabs of masking fluid to the trees to suggest snow. Use the no. 10 sable round to paint the snowy hillside in the background with cobalt blue and cadmium red. Allow to dry.

2 Use the large squirrel mop to sweep clean water across the background to just below the tree line and drop in Naples yellow on the left. Paint a line of cadmium orange beyond the trees to suggest a sliver of light.

3 Paint cobalt blue and cadmium red wet into wet from the top of the sky downwards to blend with the yellow. Soften any hard edges that appear with a damp brush. Use a smaller squirrel mop with alizarin crimson and cobalt blue to define the mountain ridge, and blend it across the sky.

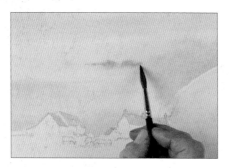

4 Wait until the sky is just damp and use the no. 7 sable round to dot in clouds with cadmium red and cobalt blue. Test at the edge of the picture to make sure the cloud wash does not spread too far in the damp background.

5 Paint the buildings with cobalt blue and burnt sienna, then drop in yellow ochre and alizarin crimson.

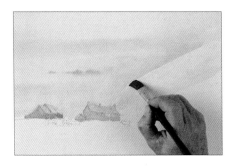

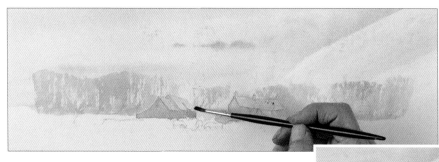

6 Use a damp 13mm (½in) flat brush to soften the line of the ridge.

7 Mix burnt sienna and cobalt blue and use the no. 4 round to paint in the background trees. Use the same mix to suggest rocks showing through the snow in the ridge.

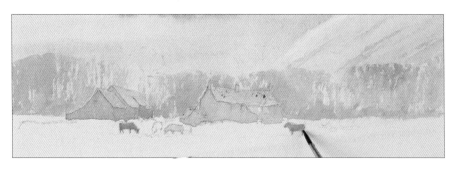

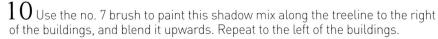

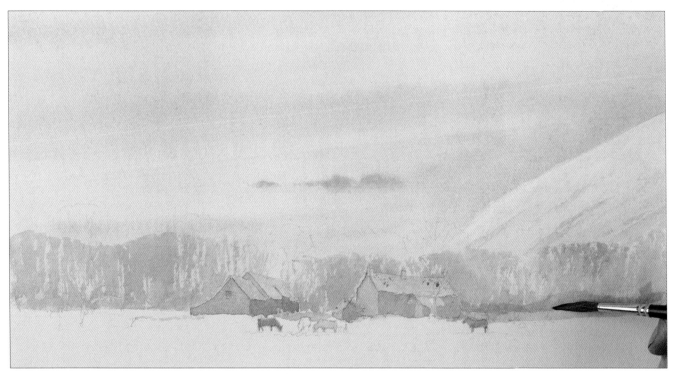

8 Paint some of the cows with Naples yellow with a touch of Indian red, then another two with burnt sienna.

9 Make a shadow mix of alizarin crimson and cobalt blue and paint the area between the buildings, then paint the shaded parts of the buildings with varying mixes of the same colours.

10 Use the no. 7 brush to paint this shadow mix along the treeline to the right of the buildings, and blend it upwards. Repeat to the left of the buildings.

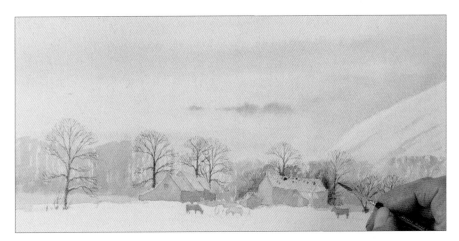

11 Use the no. 1 rigger and burnt umber with cobalt blue to paint trunks and branches on the background trees.

12 Mix cadmium red and cobalt blue and use the no. 4 round brush on its side to paint the twigwork of the trees.

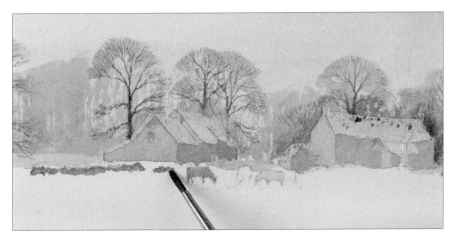

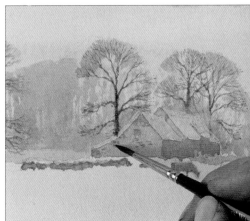

13 Paint the dry-stone wall with a mix of burnt sienna and cobalt blue, then drop in yellow ochre and alizarin crimson wet into wet.

14 Suggest the darker stonework of the buildings with a mix of cobalt blue and burnt sienna, applied wet on dry.

15 Add the darkest details of the buildings such as doors, windows and shadows under the eaves with the same mix.

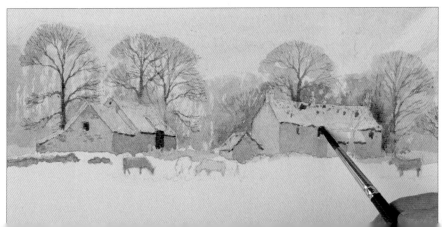

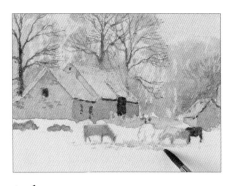

16 Add shade and detail to the cows with the same mix. Allow to dry. Paint yellow ochre under the cows for hay.

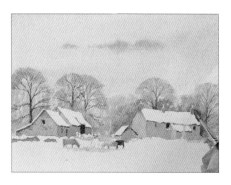

17 Remove the masking fluid. Use the no. 3 round brush to paint the chimneys with yellow ochre and the pots in Naples yellow.

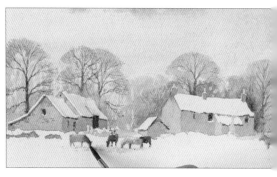

18 Paint the shadowed snowy roofs with alizarin crimson and cobalt blue. Paint the final cow with burnt umber and cobalt blue and add shadow on the others with the same mix.

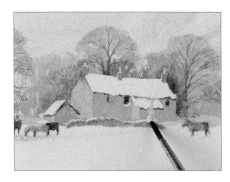

19 Paint the wall in front of the house with cobalt blue and burnt sienna, leaving white for the snow on top, then drop in yellow ochre and alizarin crimson wet into wet.

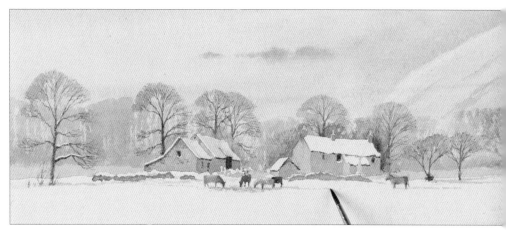

20 Use the shadow mix of alizarin crimson and cobalt blue to paint cast shadows from the trees, cows and chimneys.

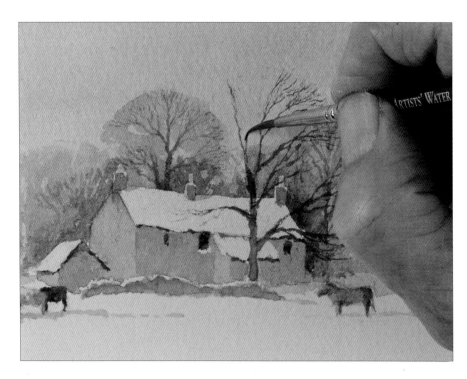

21 Mix cobalt blue and burnt sienna and paint the tree in front of the house with the no. 4 brush. While this is wet, change to the no. 3 sable round and drop in cadmium yellow pale. Continue painting twigs and branches with the brown mix.

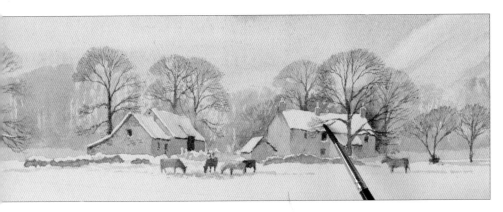

22 Paint the twigwork on the trees with cadmium red and cobalt blue, with the brush on its side and the dry-brush technique.

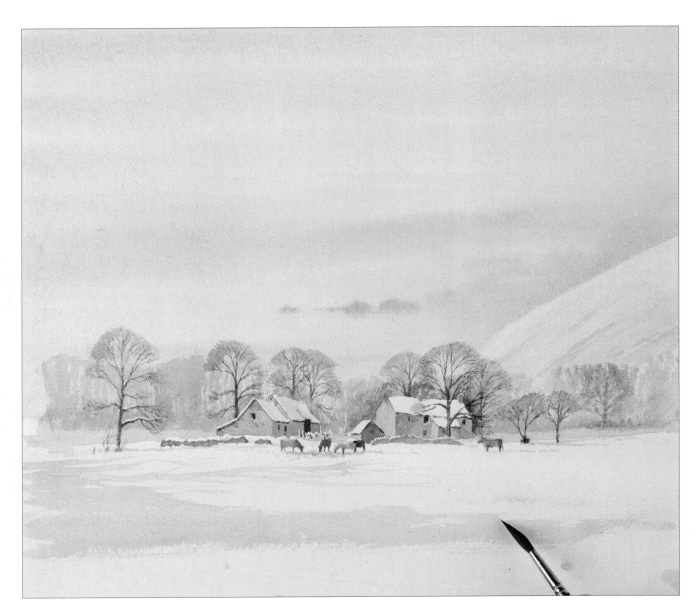

23 Strengthen the shadows beyond the house and on the buildings with a mix of alizarin crimson and cobalt blue. Use the no. 1 rigger to tidy up and add any final details. Change to the no. 7 round brush and paint cast shadows across the foreground snow from some imagined trees to the left of the scene, suggesting the contours of the land.

24 Step back from the painting to see what remains to be done. At this point, I darkened behind the snowy roofs with burnt sienna and cobalt blue, then added a little white gouache to suggest snow caught in the trees.

The finished painting

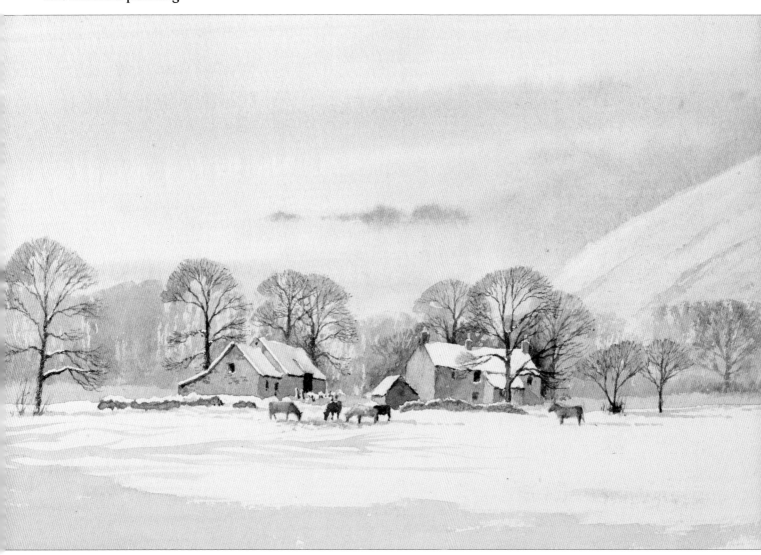

Early spring

It is often hard to spot when late winter becomes early spring, but this is a lovely time of year with the prospect of longer daylight hours and a distinct freshness in the landscape. The lovely, gentle sunny days provide an excellent time for those who are reluctant to step outside in the depths of winter, as it gives them a chance to get some original material to work from before those summer greens begin to intrude once more.

As with seeking out stunning autumn colours, it pays to look for hints of spring and the coming of warmer weather. Note the fresh colours in the grass and vegetation, and the arrival of spring flowers, often set against the warm colours of dead winter leaves and branches. Lambs seem to appear earlier every year, and in some parts of the world, nothing implies the onset of spring more evocatively. Later, of course, blossom can be introduced, making a great variation in the depiction of trees.

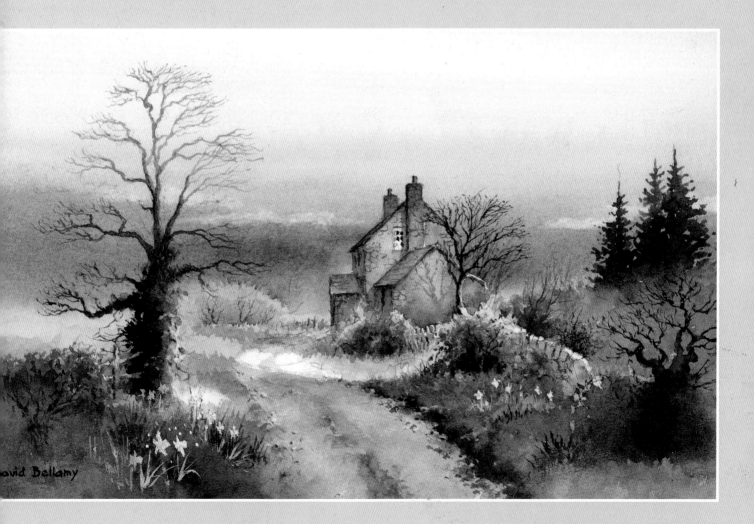

avid Bellamy

Opposite

March Sunlight

17.8 x 24cm (7 x 9½in), 300gsm (140lb) Hot Pressed

In this scene, the shadows lengthen as the day draws to a close. I wanted to capture the feeling of early spring sunlight casting shadows across the building and lane, without making them too strong. I chose a Hot Pressed surface because it is excellent for sharp detail, and here I wanted the daffodils to stand out. The daffodils were rendered by applying masking fluid first, removing it once the dark green verges were dry, and then painting in some cadmium yellow pale, which stands out well against the dark green. As daffodils have hard-edged, angular petals, the masking fluid lends itself well for this purpose.

Edge of the Wood

20.3 x 29.2cm (8 x 11½in)
300gsm (140lb) Not

Although there are still dead winter leaves around in this watercolour, signs of early spring in the form of lambs and primroses are evident. These are excellent features with which to soften the bleakness of a winter landscape, and as spring progresses, you can include blossom, bright yellow-greens and more flowers. Spring-time can be highly rewarding for those landscape painters who experience difficulties with the massed greens of summer.

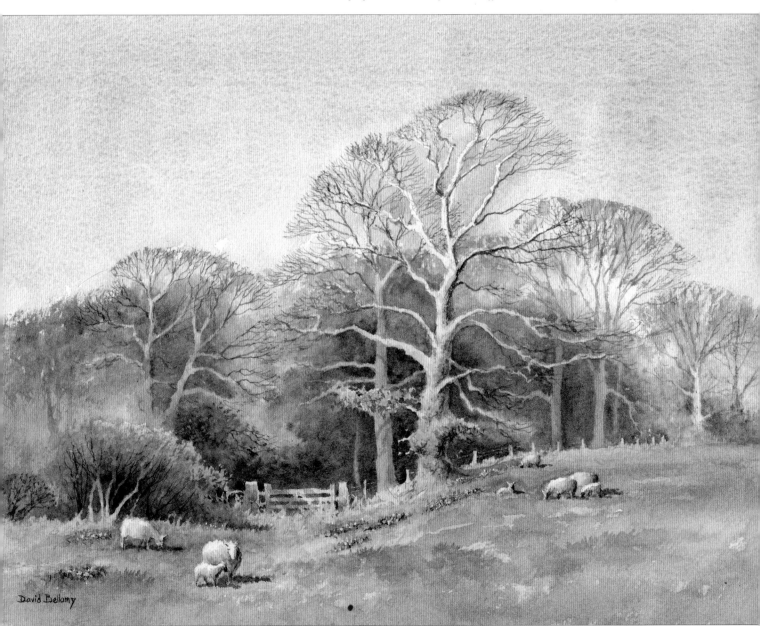

David Bellamy

AFTER THE SPRING SHOWER

There is nothing quite like a spring shower to freshen up the landscape. I take every opportunity to record these effects, as they can give a painting such a lovely sense of mood. One of the main objectives in this demonstration is to show you how to suggest the wet surface of a country lane, and a touch of sparkle on something as mundane as a muddy field.

Materials used

Saunders Waterford 640gsm (300lb) Not watercolour paper

Brushes: Small and large squirrel mops, no. 10 sable round, no. 7 sable round, no. 3 rigger, no. 4 sable round, 6mm (¼in) flat, no. 1 rigger, no. 3 sable round

Colours: cerulean blue, Naples yellow, alizarin crimson, cobalt blue, cadmium red, yellow ochre, cadmium yellow pale, burnt sienna, Indian red, light red, raw umber, new gamboge, cadmium orange, burnt umber, white gouache

Sponge

1 Use the small squirrel mop and cerulean blue to paint the sky, leaving lots of white for clouds. Do not apply water first, as you want some hard edges to appear. Soften the left-hand edges with a damp brush as these are away from the sun.

2 Change to the no. 10 sable round and paint a wet wash of Naples yellow in the lower sky and down over the distance. Drop in a little alizarin crimson to warm the colour and allow to dry.

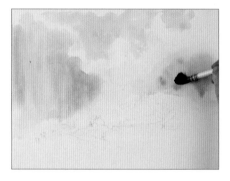

3 Wet the paper in the lower sky and distance using the large squirrel mop, then sweep down a mix of cobalt blue and cadmium red. Soften in places with a damp brush.

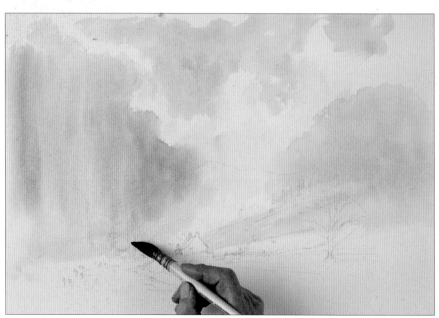

4 Paint yellow ochre from the right-hand cloud down to the building, then on the left over the foliage area. Add cadmium yellow pale in the middle distance.

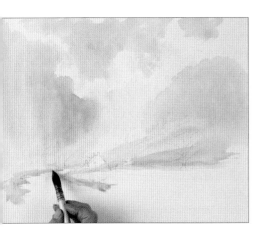

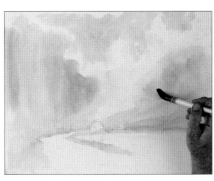

5 Mix cobalt blue with cadmium yellow pale and paint this on the fields near the house. Add Naples yellow below this, then paint the original mix in the area of the daffodils and along the road's edge. Allow to dry.

6 Use a damp sponge to soften the edge of the right-hand cloud, then paint on more cadmium red and cobalt blue with the large squirrel mop.

7 Paint the background trees with alizarin crimson and yellow ochre on the no. 7 brush, then add burnt sienna lower down.

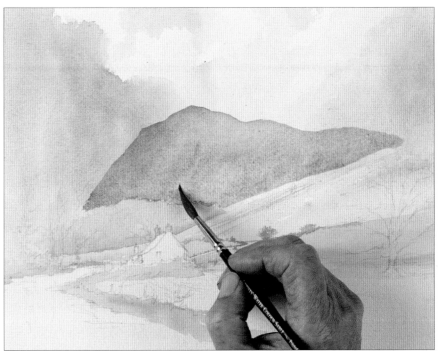

8 Paint a pale mix of cobalt blue and Indian red down the slope towards the house, indicating rough pasture. Drop in light red wet into wet.

9 Change to the squirrel mop and paint the distant mountain with cobalt blue and burnt sienna with a little yellow ochre. Drop in yellow ochre wet into wet with the no. 7 brush.

10 Soften the lower edge of the mountain with clean water as it goes behind the trees.

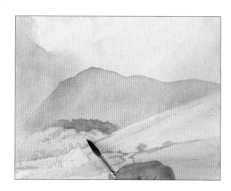

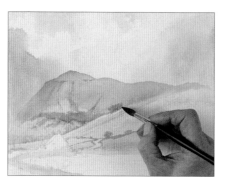

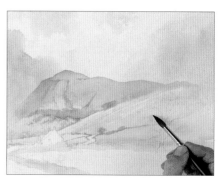

11 Mix yellow ochre and cobalt blue and use the no. 7 brush to paint the darker area of trees, then lift out some of the colour to texture the massed trees in front. Allow to dry.

12 Use a sponge to subdue the darker trees, then use the yellow ochre and cobalt blue mix to suggest gullies on the distant mountain. Extend the distant line of trees with the same mix.

13 Stand back to assess the painting from time to time. At this point I decided that the right-hand slope needed to look more spring-like, so I brightened it with cadmium yellow pale and a little cobalt blue.

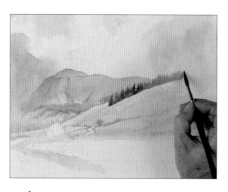

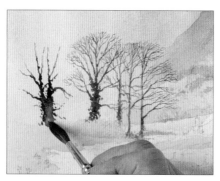

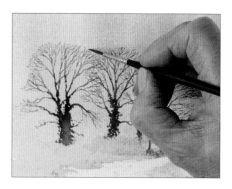

14 Paint the conifers on the right with raw umber and cobalt blue, varying the strength.

15 Use the tip of the no. 7 brush to paint the trees on the left with raw umber and cobalt blue for the trunks and the branches on the right, and burnt umber on the left. Suggest the ivy on some trunks and drop in new gamboge, then cadmium orange wet into wet.

16 Use a no. 3 rigger and raw umber with cobalt blue to build up the finer branches.

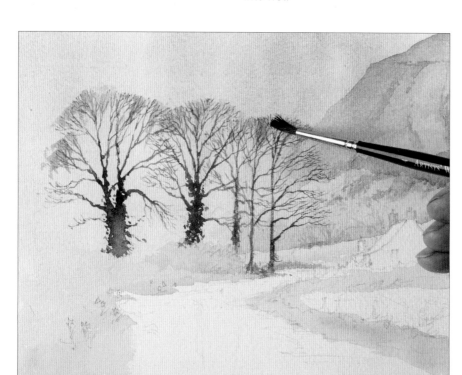

17 Mix burnt umber and cobalt blue and paint the twigwork of the trees with the no. 4 round brush on its side.

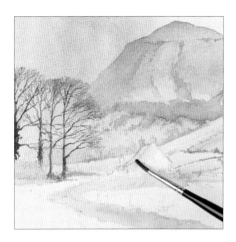

18 Paint the roof of the building with a very pale mix of cadmium red and cobalt blue.

19 Paint yellow ochre and cobalt blue under the trees for the shaded part of the hedge. Add cadmium yellow pale for the lighter part.

20 Add spots of light red for dead leaves under the trees, then mix cobalt blue with a little new gamboge to create the daffodil leaves coming forwards.

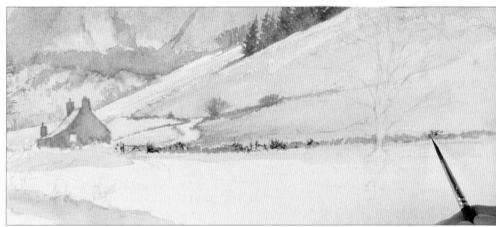

21 Paint the shaded side of the house with burnt umber and cobalt blue, then drop in Naples yellow wet into wet. Paint the chimneys in the same way.

22 Paint the hedge with cobalt blue and new gamboge, then use the no. 3 round brush with cobalt blue and burnt umber to paint the gate, fenceposts and details in the hedge.

23 Continue, painting the posts on the left of the house, the window panes and the tree behind the house.

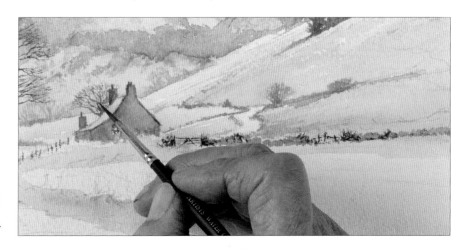

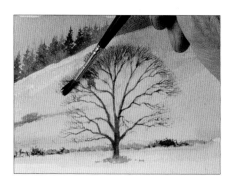

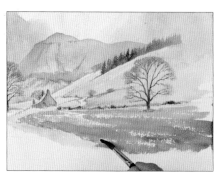

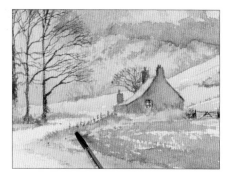

24 Use the no. 4 brush to paint the tree on the right with raw umber and cobalt blue, then drop in alizarin crimson. Change to the no. 1 rigger and a mix of burnt umber and cobalt blue to extend the branches and twigs. Use the no. 4 brush on its side to paint the twigwork with the same mix.

25 Use the no. 10 brush and burnt sienna to sweep in the ploughed field with the dry-brush technique, leaving speckles of white.

26 Paint the greenery in front of the house and along the fence with the no. 4 brush and cadmium yellow pale, then drop in raw umber.

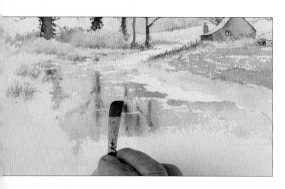

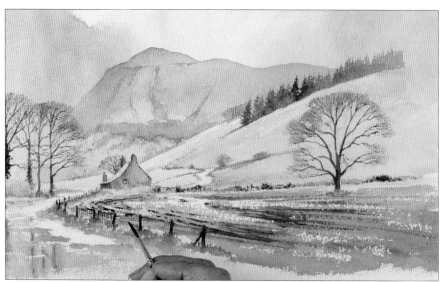

27 Use the no. 10 brush on its side to sweep cobalt blue and burnt umber from side to side across the foreground track, picking up the paper texture. While the paint is wet, paint reflections with a darker mix, then lift out colour with a just-damp 6mm (¼in) flat brush, suggesting ripples.

28 Brighten the grass verge beside the track with cadmium yellow pale and cobalt blue on the no. 4 brush, then use the no. 7 brush and burnt umber with a touch of cobalt blue to paint furrows and texture in the ploughed field. Add fenceposts with a darker mix of the same colours, then paint a darker mix of the previous green for grasses. Add netting to the fence with the no. 1 rigger and the brown mix.

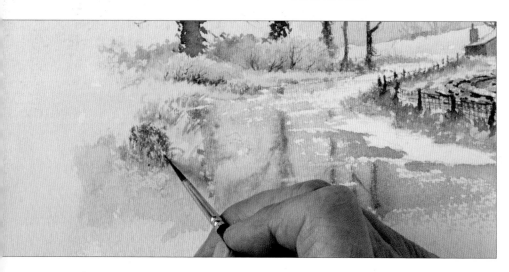

29 Paint the daffodils with white gouache, then cadmium yellow pale. Paint negatively around them with cobalt blue and cadmium yellow pale.

Index

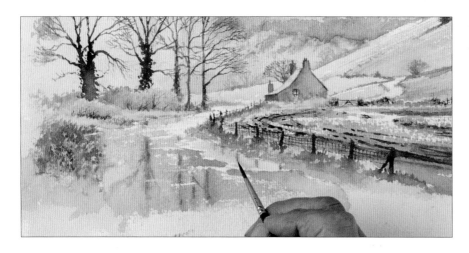

30 Clean up any pencil marks, then use the no. 7 brush and cobalt blue with cadmium red to add dark touches to the puddle, reflecting the sky. Add fencepost reflections to the road with burnt umber and cobalt blue.

The finished painting

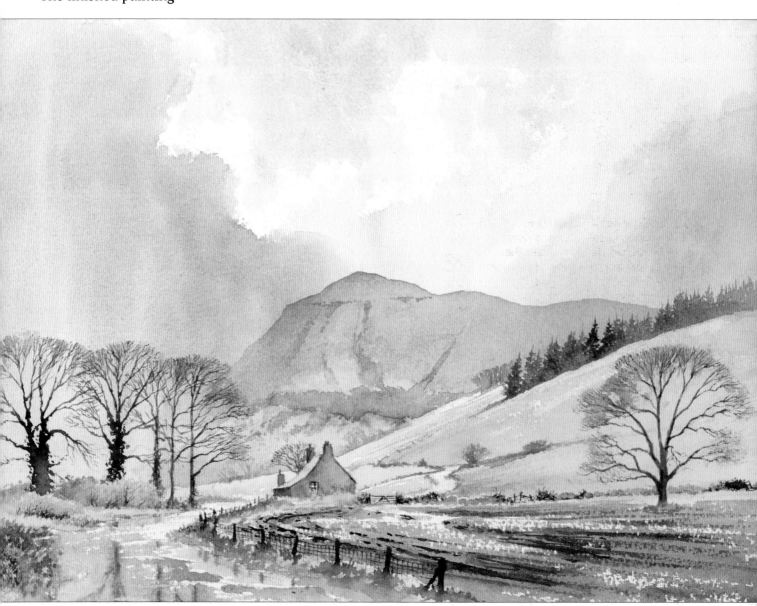